IMAGES
of America

WINDSOR LOCKS

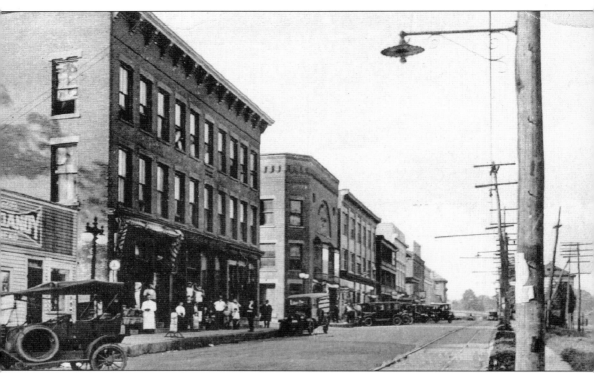

The railroad, the trolley, and the automobile all helped make the Mather Block a very busy place. (WLS.)

IMAGES
of America

WINDSOR LOCKS

Leslie Matthews Stansfield

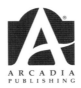

ARCADIA
PUBLISHING

Published by Arcadia Publishing
Charleston SC, Chicago IL, Portsmouth NH, San Francisco CA

Printed in the United States of America

Library of Congress Catalog Card Number: 2003107817

For all general information contact Arcadia Publishing at:
Telephone 843-853-2070
Fax 843-853-0044
E-mail sales@arcadiapublishing.com
For customer service and orders:
Toll-Free 1-888-313-2665

Visit us on the Internet at www.arcadiapublishing.com

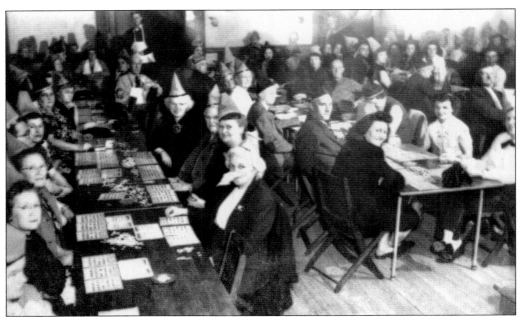

Bingo night at Memorial Hall is shown in this World War II–era photograph. (WLHS.)

CONTENTS

ACKNOWLEDGMENTS

I am very grateful to the Windsor Locks Historical Society (WLHS) for allowing me access to its collection of photographs. The Windsor Locks Police Department (WLPD) and Windsor Locks Fire Department (WLFD) allowed me to take pictures right off their walls. In addition, I wish to thank all the seniors at the senior citizen center who pored over pictures to help identify people and places.

Tom Palshaw of the New England Air Museum (NEAM) went through photograph albums of the Prof. N. Edward Tolbert collection to help me find some photographs taken from the air and some other photographic treasures as well.

The Thomas Dodd Research Center (TJDRC) at the University of Connecticut (UCONN) allowed me to use photographs from its collection as well.

Finally, I am extremely fortunate to have made the acquaintance of the following people who shared their family pictures and life stories with me: Cornelius O'Leary (CO); Michael Smalley (MS); William L. Sizer (WLS); Beverly Church, Windsor Locks Women's Club (WLWC); Elizabeth Magnani (EM); Jule Ann Fiochetta (JAF); Julie Lynes (JL); Katie Scotto (KS); Mary Ann Gianelli; and Mary "Tiny" Pasco (MTP).

I am indebted to the following publications for help during my research of the history of Windsor Locks: *The History of the Church of Saint Mary* (1954), *150th Anniversary of the Church of Saint Mary's, The Story of Windsor Locks* (1954), and *The Story of Windsor Locks 1663–1976* (1976).

INTRODUCTION

The story of the town of Windsor Locks began in 1663, when Henry Denslow, a settler from Windsor, Connecticut, purchased land in what was referred to as Pine Meadow. Pine Meadow became Windsor Locks in 1854. The first three settlers in this area, all from Windsor, were Henry Denslow (in 1663), Nathaniel Gaylord (in 1678), and Abraham Dibble (in 1708). In 1675, during a Native American uprising, the Denslow family fled to Windsor for safety. In April 1676, however, Henry Denslow left his wife, son, and seven daughters in the safety of the fort at Windsor and ventured back to his land. He was never seen again. Evidence indicates he was killed by a party of Native Americans. His 17-year-old son succeeded his father as a pioneer, and descendants of the Denslow family still live in town today.

I love the history of Windsor Locks because it encompasses most everything I learned in school about the building of America. Settlers fought with Native Americans for land. Businesses grew along waterways. The men of Windsor Locks served in the Revolutionary War. The escalation of industry followed the war. The canal came and brought with it a boon for businesses. The railroad arrived. World War II brought the growth of an airport, and the area was developed in the post–World War II era.

In time, we all look back at the years we spent on this earth and reminisce about people, events, and places. Each person has his own story to tell. Like diamonds, no two stories are ever the same. It has been my pleasure to mine these stories from a number of the senior citizens in Windsor Locks. Many of them were children of immigrants, who came here with nothing but the clothes on their backs, dreams in their hearts, and determination that is seldom seen today. These immigrants worked in the factories, built the canal, built the railroad, started their own businesses, and raised their families. Other seniors are descendants of the original English settlers, who braved countless hardships to begin a new life here. Although the stories are all unique, they all have the common thread of community. Whether they were Yankee, Irish, Italian, or Polish, neighbor helped neighbor. It is my hope that as I relate their stories, you too will fall in love with the town of Windsor Locks and the people who built it.

One

BUSINESSES
AND BUILDERS

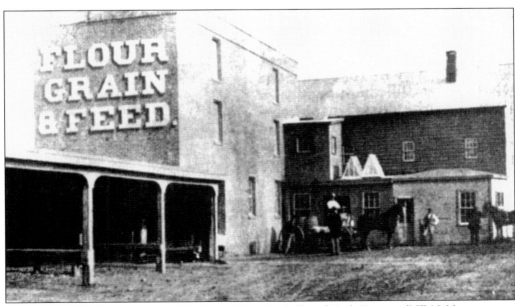

Pictured here is the first gristmill built by Jabez Haskell and Seth Dexter. (NEAM.)

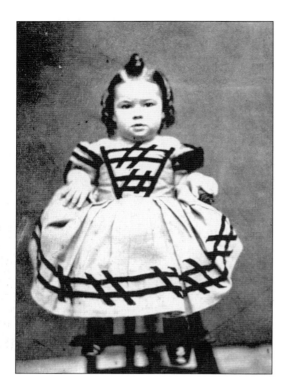

This adorable little fellow is Henry Carey Denslow (1867–1944), a descendant of the early settlers. (WLHS.)

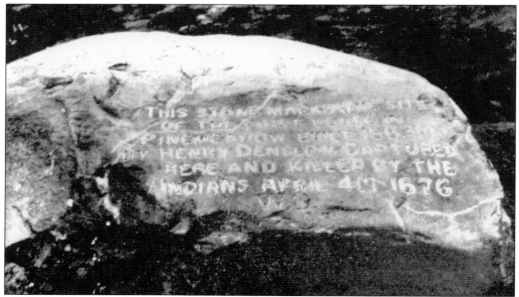

The Denslow stone, a monument to the town's first family, stands 1,500 feet east from its original site to preserve it from highway construction. It reads, "This stone marks the site of the first house in Pine Meadow, built in 1663 by Henry Denslow captured here and killed by the Indians April 4th, 1676." (WLHS.)

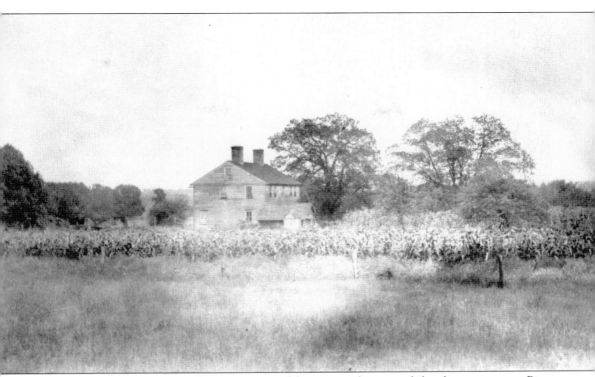

The Gaylord family, whose home is pictured here, was the second family to move to Pine Meadow (Windsor Locks). This house, built in 1678 by Nathaniel Gaylord, stood as a monument to them until 1989, when it was torn down to make room for Route 91. The road this home stood on was called Gaylord Road. (WLHS.)

In 1767, an event occurred that greatly contributed to the growth and industrialization of Windsor Locks. That year, Jabez Haskell and his brother-in-law Seth Dexter arrived from Rochester, Massachusetts. Dexter later purchased the sawmill on Kettle Brook and water privileges with land for a mill and shop. This harmless-looking brook, Kettle Brook, is where the industry of the town started. Prior to the building of the canal, the brook supplied the waterpower for the mills. Dexter built a mill near the brook in 1770 and introduced the nation to the art of wool-carding and cloth-dressing, which greatly improved clothing. (MS.)

Soon after the purchase of the land and sawmill, Seth Dexter deeded the property to his son, also named Seth Dexter, who is pictured here. (WLHS.)

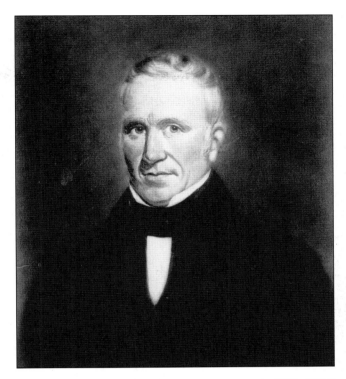

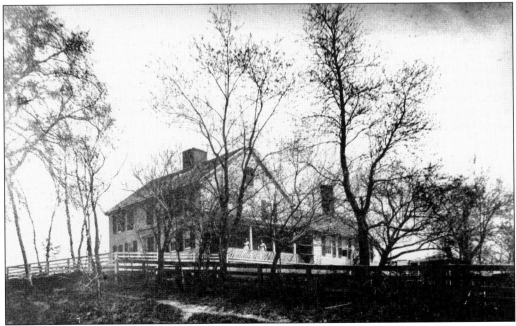

Two women look down from the porch of the Seth Dexter house on Center Street in 1888. Sense the chill in the air as fall sets in. The trees have lost most of their leaves, and the long summer days are past. The house sits alongside the dirt road, quietly awaiting the snows of winter. (WLHS.)

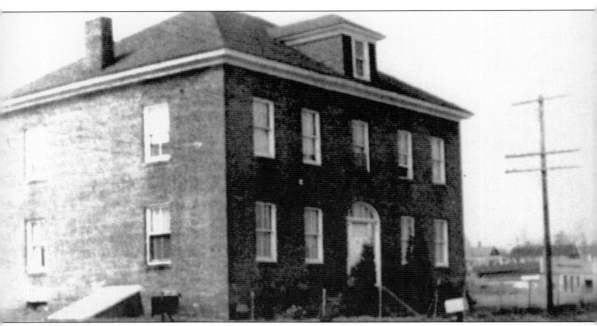

Windsor Locks was in a prime place for business because it was located on the banks of the Connecticut River, which brought trade and freight from all over. Prior to the building of the canal, river men poled their scows upstream. They stopped for refreshment at the Old Yellow Tavern, pictured here. (WLHS.)

The Dexters were not the only ingenious inhabitants. This is David Birge's woodworking shop, where the first one-horse wagon, the Birge wagon, was made. The wagon was first built in 1815. The chaise, a two-wheeled, one-horse wagon, existed at that time, but it was too expensive for general use. The Birge wagon was perfect for families that attended church in Windsor. Before the Birge wagon, people walked or went on horseback. The very first owner of the Birge wagon was Moses Mitchel, who lived on Center Street. (WLHS.)

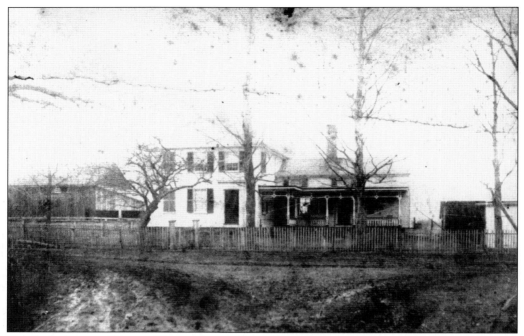

This is the home of Horace Birge, a descendant of David Birge. The Horace Birge house burned down on February 20, 1885. Willis Birge, Horace's son, built his home on its foundation. Notice the track marks in the mud from the horse-drawn carriages. (WLHS.)

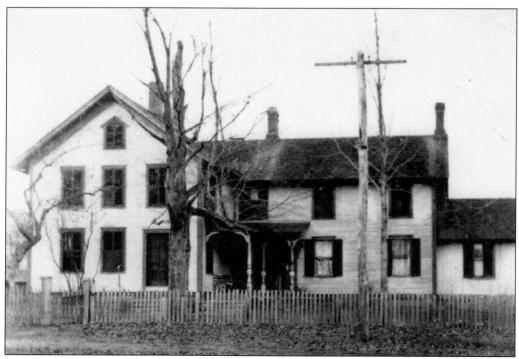

Pictured here is the home of Willis Birge. (WLHS.)

A dapper Willis Birge is seen here at age 21. (WLHS.)

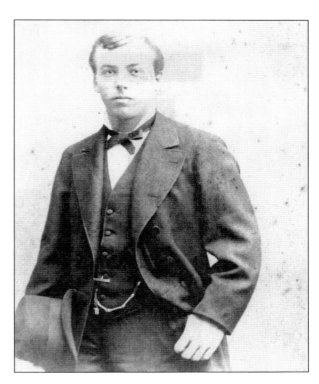

Willis Birge is pictured c. 1954. (WLHS.)

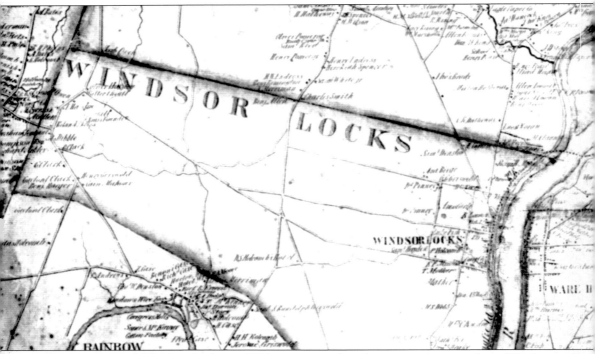

This is a map of Windsor Locks in 1855, one year after the town split away from Windsor. What is fascinating about this map is that instead of street names, the map is labeled with the names of the property owners. They seem to be in two clusters, with the middle of the town open. Around the river, there is the sawmill and family names including Denslow, Mather, and Birge. Near the Granby line, to the left, is another cluster of names. One of the names is Dibble. Arriving in 1708, Abraham Dibble was one of the first three settlers in Windsor Locks. Today, the name Dibble is remembered by the section of town called Dibble Hollow. (SWL.)

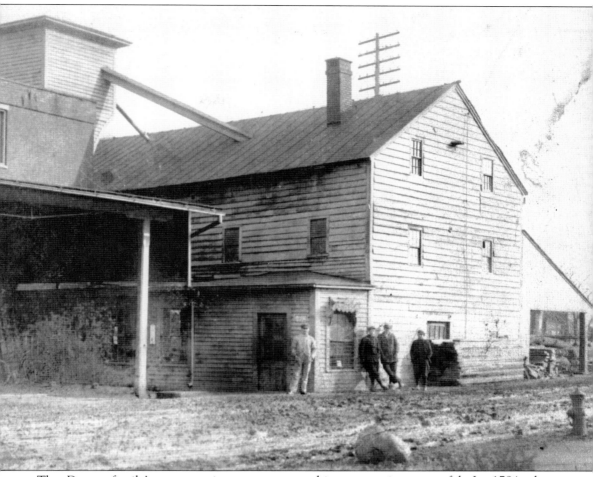

The Dexter family's ventures into entrepreneurship were quite successful. In 1784, the Haskell-Dexter team built a gristmill below the old sawmill. This gristmill, pictured here in 1910, was the second built by Haskell and Dexter. It was built in 1819 near a dam at Kettle Brook. The first gristmill was shut down when the waterpower needed to operate it was destroyed by the canal. It served as a storeroom for the C.H. Dexter paper plant. These gristmills were the source of ground flour and meal for neighboring farmers. This gristmill was torn down in 1925, and papermaking would eventually become the source of the family's wealth. The mud road in front is Main Street. (WLHS.)

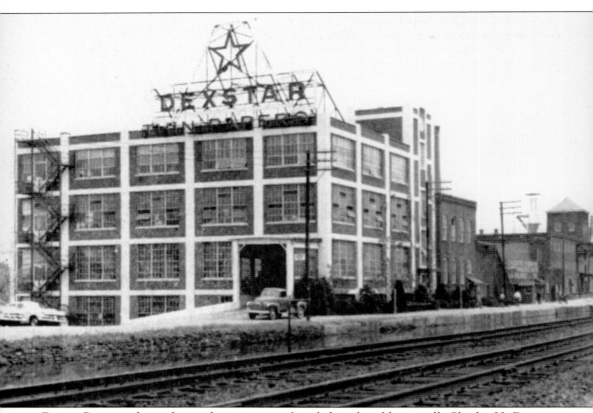

Dexter Paper, makers of specialty paper, was founded in the old gristmill. Charles H. Dexter, son of Seth Dexter, began experimenting with specialty paper in the basement of the gristmill. Specialty paper comes in many types and has many uses, including tea bags. Charles H. Dexter succeeded his father in running the business. In 1867, Charles H. Dexter's son Edwin and son-in-law Herbert R. Coffin joined the business, and the name of the company became C.H. Dexter and Sons. When Edwin Dexter died in 1886, Herbert R. Coffin assumed control of the business. In 1914, the company was incorporated as Herbert R. Coffin's Sons. Arthur D. Dexter and Herbert R. Dexter were the president and vice president. (WLHS.)

Pictured is Charles Haskell Dexter, who began the experiments with specialty paper. In 1833, a post office was set up at the gristmill, and Charles H. Dexter was the postmaster. (WLHS.)

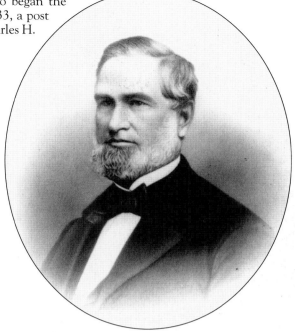

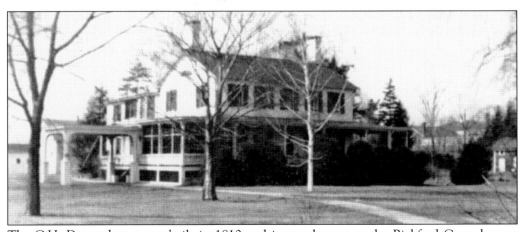

The C.H. Dexter house was built in 1810 and is now known as the Bickford Convalescent Home. Before the canal was built, the front yard of the property extended down to the river. The house was moved to its current location in the early 1820s. (WLHS.)

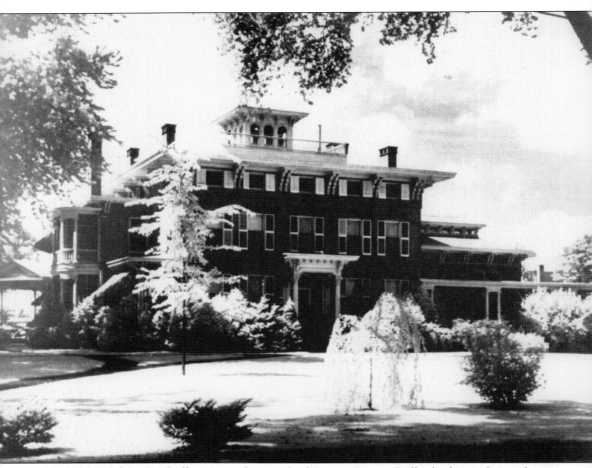

In 1886, Herbert R. Coffin assumed control of Dexter Paper. Coffin built an elegant home, which was known as Ashmere due to the lovely ash trees that graced the property. The home was magnificent both inside and out. The grand Ashmere stood tall and proud on Main Street. (WLHS.)

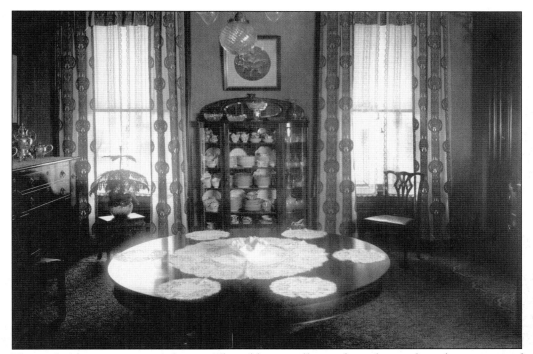

This is the dining room at Ashmere. The table is small, just the right size for a dinner party of six. The silver tea set adorns the butler's table on the right. The hutch is filled with china ready to be used. Above, the gaslight would have added its soft whisper to the background music of clinking dishes. (WLHS.)

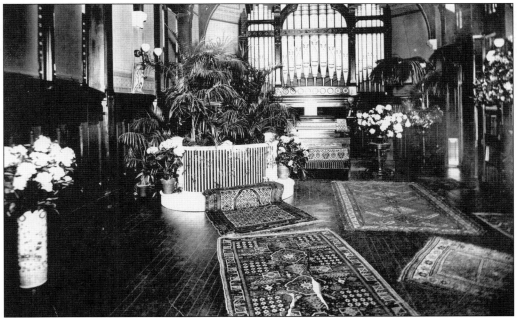

Pictured on December 11, 1906, is the music room at Ashmere, decorated for the wedding of Thomasine Haskell to George Conant. (WLHS.)

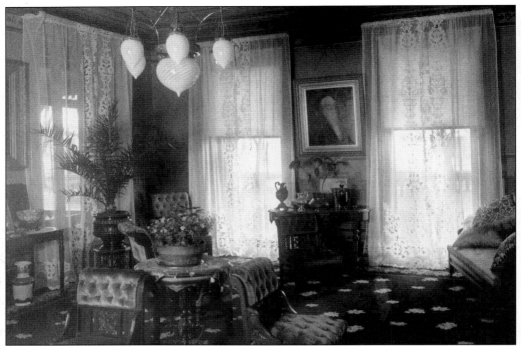

This parlor at Ashmere, not as formal as the best parlor, would have been used for more casual gatherings. Pictures of ancestors adorn the walls. Sheer curtains with shades behind them bedeck the windows. Notice the couch and chairs, which do not seem as inviting as the furniture of today. (WLHS.)

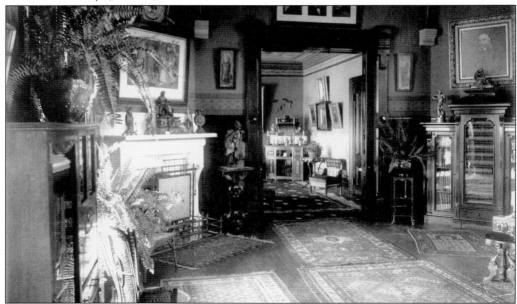

In the best parlor, lovely rugs adorn the hardwood floors, and a painted screen stands in front of the fireplace. Notice that there are no lamps in the picture. The Coffins would have entertained their friends in this room. (WLHS.)

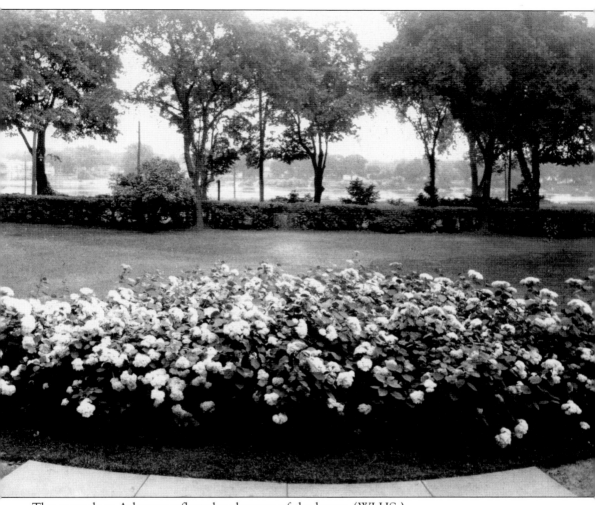

The grounds at Ashmere reflect the elegance of the home. (WLHS.)

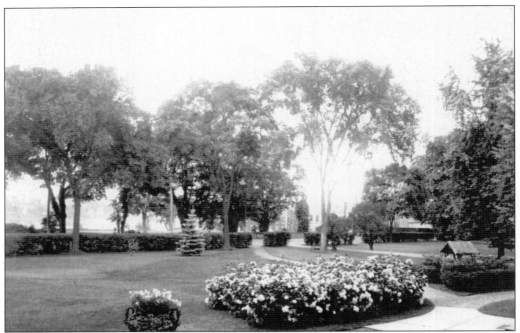

Imagine strolling through the grounds on a cool summer evening. (WLHS.)

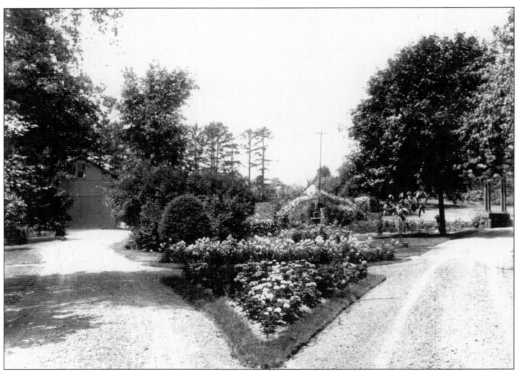

Notice the shed on the left. Keeping the grounds exquisitely groomed took an extremely talented groomer. (WLHS.)

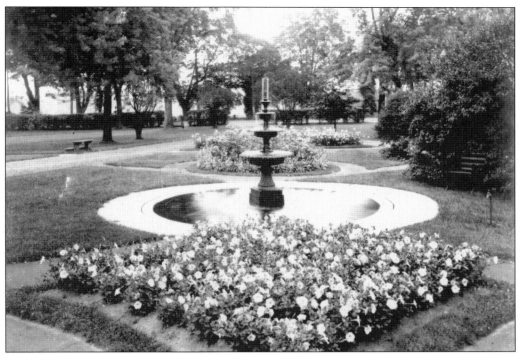

It must have been relaxing to stroll the grounds after a hard day at Dexter Paper. (WLHS.)

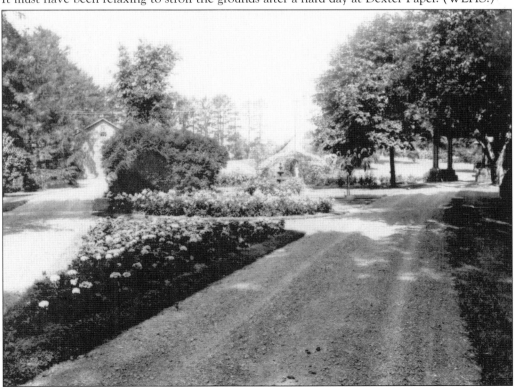

The E. Horton and Son Company was known for its lathe chucks. In 1851, Eli Horton obtained a patent for a universal chuck, and breaking away from a factory in West Stafford, he and his son Stoddard started the E. Horton and Son Company. When Eli Horton died in 1878, he left the business to his son-in-law Ezra Bailey. The company sat on the banks of the canal. (WLHS.)

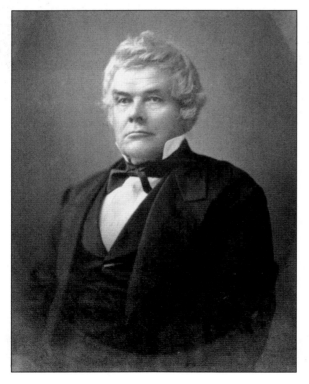

This distinguished-looking gentleman is Eli Horton, the inventor of the wood lathe. (WLHS.)

The Bailey house, also the home of Eli Horton, is pictured in the spring. Ivy adorns the front porch and the chimney on the left side. Look at the roof and notice the two chimneys. It must have taken a number of fireplaces to keep the house warm in the winter. The water pump on the front lawn indicates that when the house was built, there was no running water inside. (WLHS.)

Ezra Bailey and his son Philip share a moment together c. 1900. (WLHS.)

With her puffed sleeves and a big flower on her dress, Katie Bailey is all set to go for a ride in her carriage. (WLHS.)

This is the home of Charles Holbrook, who manufactured school supplies in a factory on Center Street. (WLHS.)

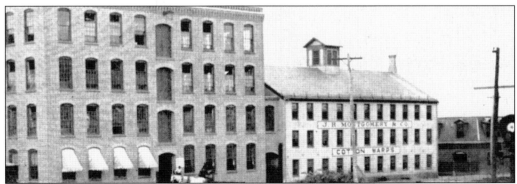

Montgomery Company, pictured here c. 1890, was established in 1871. J.R. Montgomery came from Housatonic, Massachusetts, to establish the plant, which sat on the canal bank at the lower end of the locks. Here, cotton warp yarns were produced for weaving into specialty fabrics. (WLHS.)

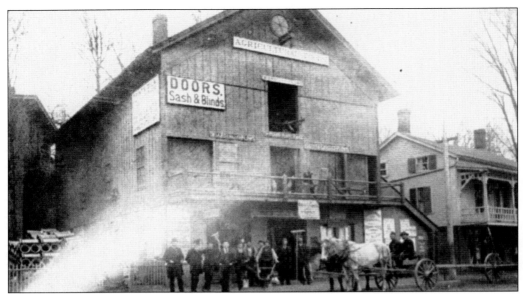

This is the F.S. Bidwell Company *c.* 1892. The business began in 1875, when T.I. Pease of Thompsonville bought the lumber business of H.C. Douglas and Company of Windsor Locks. In 1888, Mr. Pease's nephew Fredrick Bidwell bought out his uncle. The business expanded and eventually moved to its well-known location on Main Street. According to *The Story of Windsor Locks*, the January 25, 1951 issue of the *Windsor Locks Journal* stated, "The F.S. Bidwell Company is an integral part of the business life of the town and its reputation is as sound as its years of service." (WLHS.)

This is the Medlicott Company building, which was located just south of where the new bridge (built in 1991) stands. The bell from the building's tower is located on the grounds of the Windsor Locks Volunteer Fire Department as a memorial to deceased members of the department. (WLHS.)

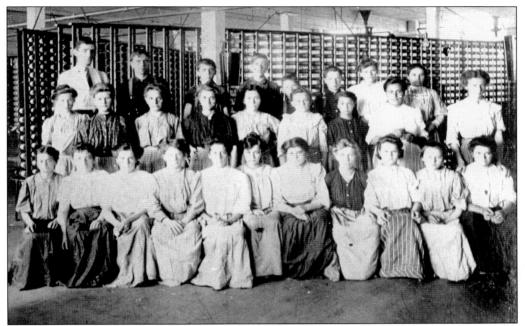

This is a group of workers at the Medlicott factory. Behind them are spools of thread. Notice the number of children in the picture. Children often worked in the factories to help their parents financially. The second woman from the right in the second row is believed to be the mother of Michael Smalley. (MS.)

Incorporated in 1901, the plant of the George P. Clark Company was located on a piece of land on the canal between the Electric Light Company and the Windsor Silk Company. At the time, the Electric Lighting Company offered its services only at night, so it was necessary for the George P. Clark Company to supply its own electricity. The factory thrived. During both world wars, the company supplied large numbers of special material handling equipment. (WLHS.)

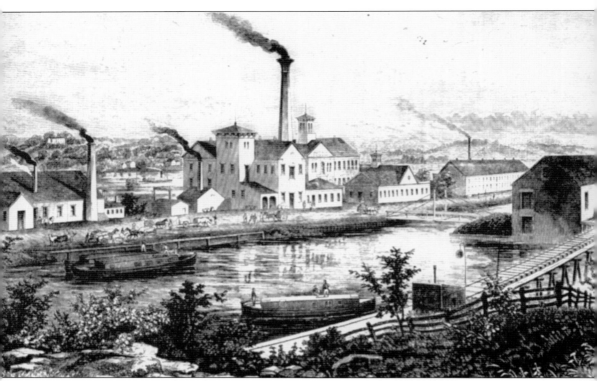

Dexter Paper was not the only paper company. In 1844, Persse and Brooks bought the Windsor Manufacturing Company. By 1857, it was said to be the largest paper mill in the world. The plant ranged over most of the canal bank north of the Medlicott building. Shortly after 1857, a great panic forced the paper mill into decline. It was purchased by the American Writing Paper Company in 1898. The business was subsequently moved to Holyoke, Massachusetts, and the building no longer exists. Pictured here is the Persse and Brooks paper mill during Civil War times. (WLHS.)

Two

A Peep at the Past

The railroad came to town in 1844, bringing immigrants and their hopes. (MS.)

The Noden-Reed House, the home of the Windsor Locks Historical Society, has an interesting history. The property was originally owned by the great-grandson of Henry Denslow, Samuel Denslow, who built a house on it in 1762. The original farm had a small cabin for his hired hand, Hendrick Roddenmore, a Hessian soldier. According to tradition, in 1777, Roddenmore showed the Denslow family the Hessian tradition of decorating a Christmas tree. Thus Windsor Locks claims to be the home of the first Christmas tree in this area. In 1785, the property was passed to his son-in-law Martin Pinney, who built a new house on it in 1840. On December 24, 1919, the house became the home of Chester Reed. (WLHS.)

A room inside the Noden-Reed House is decorated for Christmas. One wonders if Samuel Denslow would be surprised that the "tree thing" caught on. (WLHS.)

Hanna Noden-Reed, the matriarch of the Reed family, is the namesake of the Noden-Reed House, which is now the home of the Windsor Locks Historical Society. (WLHS.)

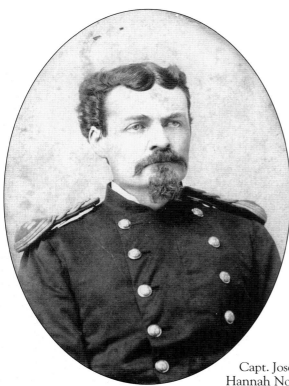

Capt. Joseph Reed, shown here, was the husband of Hannah Noden-Reed. (WLHS.)

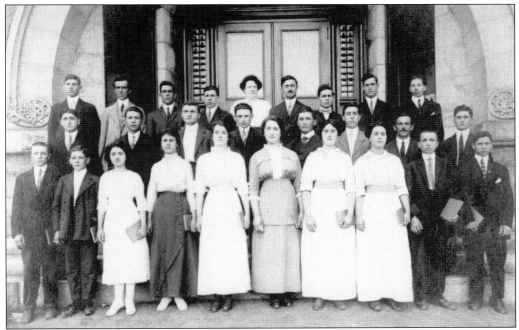

As Windsor Locks began to thrive due to the growing businesses along the canal, immigrants began coming to the town looking for work. The canal itself was built by many Irish immigrants. There were also a number of Italian and Polish immigrants. In order to help them thrive within the community, Julia Haskell Coffin and her daughter Thomasine Haskell Conant started the Lincoln School. The school's goal was to help immigrants learn English; the women were also taught housekeeping skills. This picture shows the students of the school in 1913–1914. (WLHS.)

Thomasine Haskell Conant is seen here in her mother's rose garden. (WLHS.)

The Reed sisters pose for a photograph. Hazel, on the right, does not seem amused. Note that the sister in back is wearing a lovely broach. The other three girls wear pendants. (WLHS.)

Olive Reed relaxes at home with her dog Sandy. (WLHS.)

Gladys Reed tends to the horses on the farm while Sandy puts in her two cents. A number of adults today look back at their childhood years and remember Reed proudly showing them her beloved horses. The building on the right is the brick barn built by Martin Pinney in 1826. It is one of the few brick barns in New England. (WLHS.)

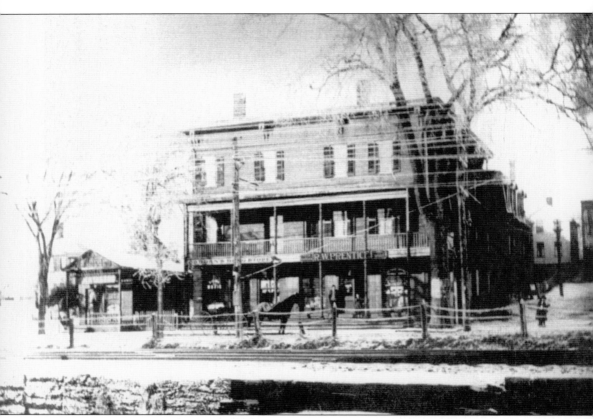

This is the Coogan Building *c.* 1900. Notice the horse and carriage tied up in front. This building was located at the corner of State and Main Streets. The Coogan and Benson families lived on the second floor. The third floor was a hall. Next to the store on the left was an undertaker's parlor. (WLHS.)

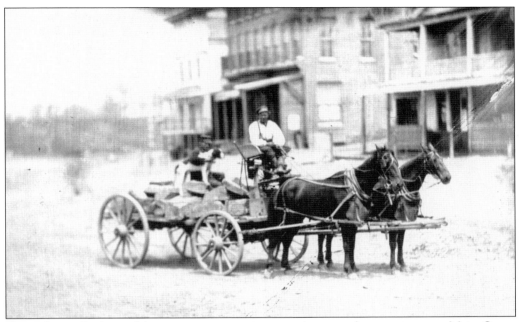

Henry Lewis Drake and his canine companion pose in a two-horse wagon on Main Street c. 1885. (WLHS.)

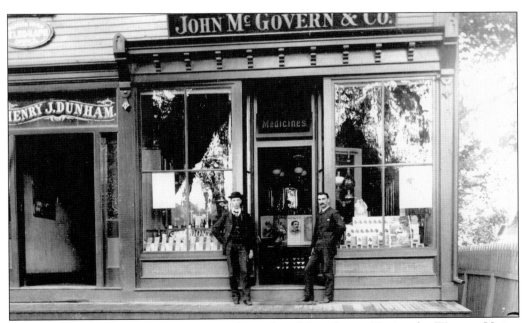

John McGovern and Company was once located on Main Street. Notice the Western Union Telegraph sign in the upper left. The walkway in front of the store is wood instead of the brick or cement common today. The writing above the door says, "Medicines," and the smaller writing below it on the right says, "Stomach." However, the window displays show pictures and figurines. Perhaps it was a type of general store. (MTP.)

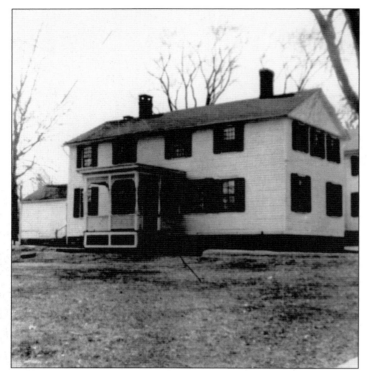

This building was constructed in 1784 by Haskell and Dexter to be used as a store. In 1833, with the canal completed, the town became Windsor Locks. The building was then used as a post office, with Charles H. Dexter as postmaster. (WLHS.)

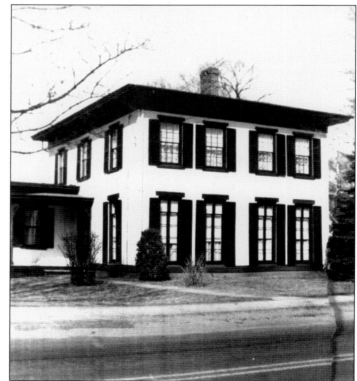

This house on Elm Street, known as the James Goodwin House, was built c. 1842. Notice the long full-length windows across the front of the house. The property was later owned by the Medlicott Company and was a two-tenement residence. (WLHS.)

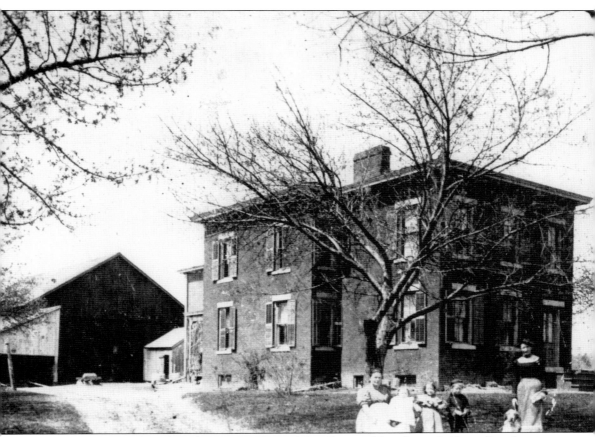

Sitting in front of the Ahern home in 1902 are Mrs. Shea and her three children. Standing is Margaret Ahern. (WLHS.)

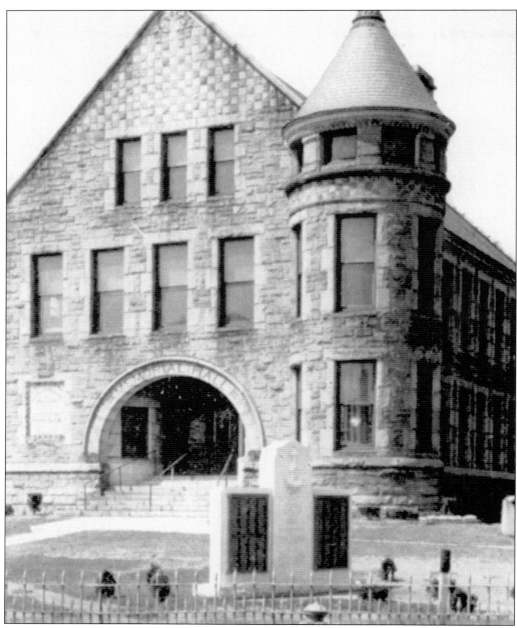

During the Civil War, 164 men were enlisted in the Grand Army of the Republic. Sixteen of them lost their lives in the war. The men lost were Joseph H. Converse (a major), Samuel S. Hayden (a captain), Horace E. Phelps (a first lieutenant), Edward Cobberly, William DeWitt, Wellington Jackson, William Porter, Michael Agon, Noble H. Bennett, Thomas E. Bradbury, Charles A. Cobb, James Coulter, James Donahue, Oliver Easton, Abel Gaylord, and William H. Strong. To honor these men, Charles E. Chaffee, president of the Medlicott Company, built Memorial Hall, pictured above, in 1891. It was built on the site of the old Haskell home. Chaffee felt a self-imposed obligation to honor the men who gave their lives to preserve the life of the nation. (SWL.)

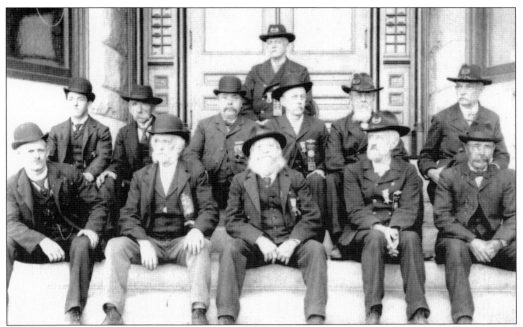

Members of Converse Post, Grand Army of the Republic, No. 67 are seen here on the steps of Memorial Hall in 1903. (WLHS.)

Pictured here is John Oates, a Civil War veteran from Windsor Locks. Many of his descendants still live in town today. (JAF.)

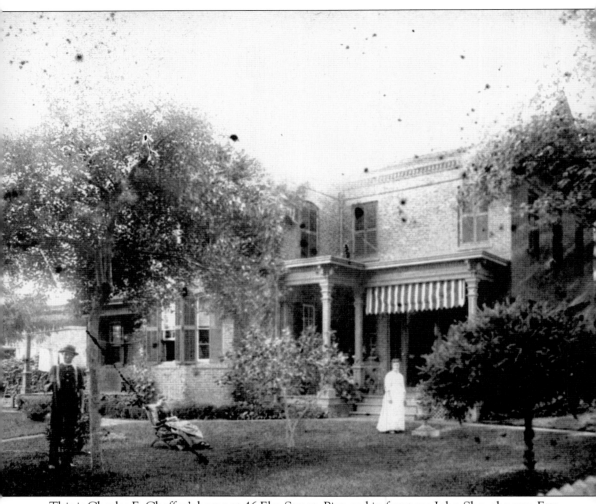

This is Charles E. Chaffee's home at 46 Elm Street. Pictured in front are John Shaughnessy, Etta Chaffee, and Mary Talbot. (WLHS.)

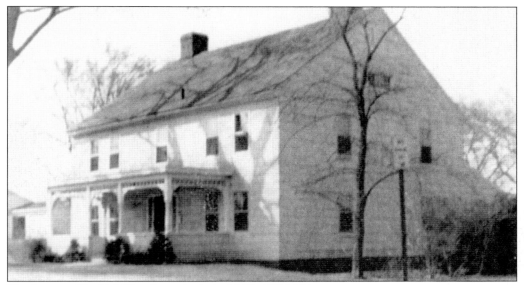

The home of Ezekiel Thrall was built in 1765. (WLHS.)

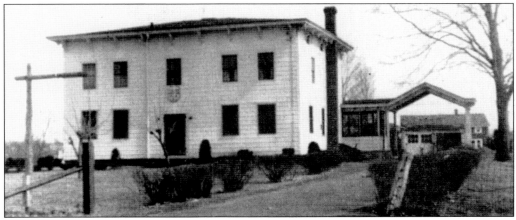

This home was built in 1776 by Capt. Martin Denslow, a direct descendant of Henry Denslow. (WLHS.)

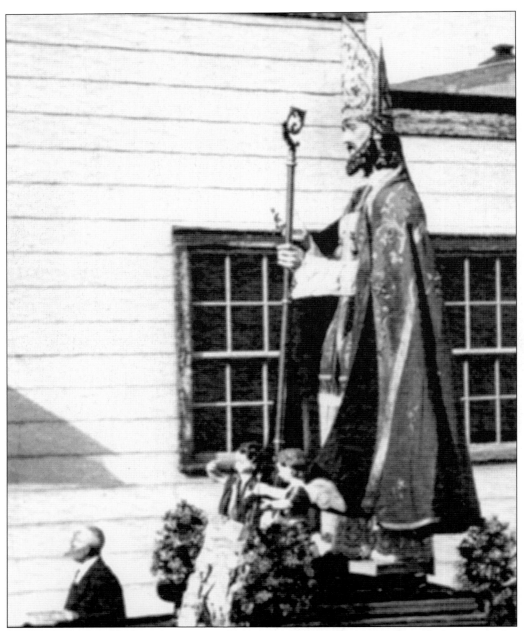

In 1919, a group of Italian-Americans who emigrated from Turi in southern Italy organized a society in honor of their patron saint, St. Oronzo. As pictured here, the statue was paraded through the town, and festivities concluded in a nearby park. According to the 150th anniversary book of St. Mary's, there was a time that the statue seemed to be held captive. In 1962, the church demanded a fee of $80 to allow the statue to be taken out and paraded through town. The people were in an uproar and decided to take matters into their own hands. A group of devoted followers went to the church and took the statue, despite the protests of Father Finnance, the priest at the time. The story states that Father Finnance was so incensed by this act that he had a stroke and died. (WLHS.)

These children wait in the back of the truck as their mother chats. Note the old Coke machine on the left and the gasoline pump to the right of the open bay door. (WLHS.)

A young Ezra Bailey is out for a ride. (WLHS.)

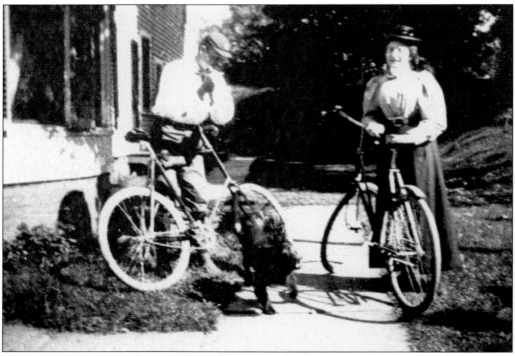
These two people, probably members of the Bailey family, are ready for a bike ride. Note the large tires. (WLHS.)

The trees cast their long shadows on the fresh snow in the front yard of the Bailey home. The dog in the yard looks ready to play. (WLHS.)

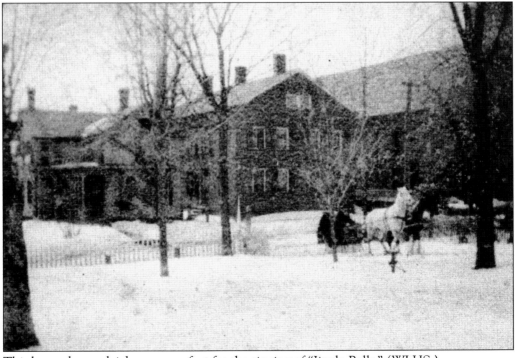

This horse-drawn sleigh seems perfect for the singing of "Jingle Bells." (WLHS.)

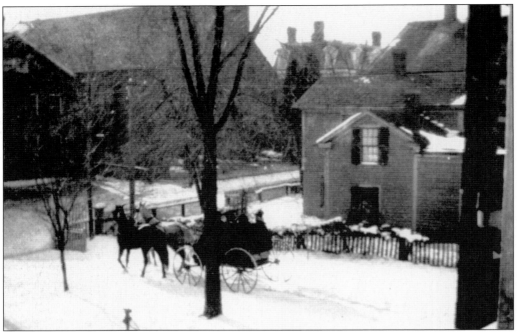

A horse-drawn carriage makes fresh tracks in the snow as it approaches St. Mary's. Notice all the chimneys that dot the skyline. The picture appears to have been taken from the Bailey home. (WLHS.)

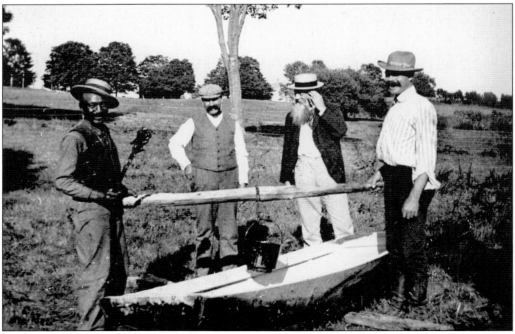

Ezra Bailey (third from left) and Philip Bailey (far right) work with two unidentified men to build a canoe during a camping trip. Perhaps they are planning a fishing trip on the Connecticut River. (WLHS.)

An unidentified man takes a stroll through town. (WLHS.)

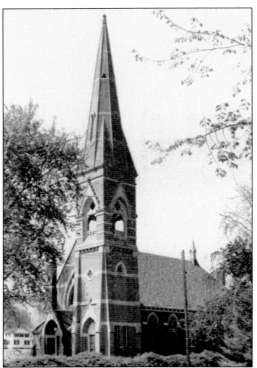

The Congregational Church of Windsor Locks was founded in 1844. It was officially organized on February 28, 1944. The original members were Herlehigh and Arathusa Haskell; Asa B. and Elizabeth Woods; Charles H. and Lydia Dexter; Sylvia Dexter, widow of Seth Dexter Jr.; Betsey Fish, wife of Luke Fish; Eliza and Mary A. Pickett; Jabez H. Hayden; Anna and Oliver Hawley from Poquaonock; Myron S. Webb from Bennington, Vermont; and Hannah Allen from Barre, Massachusetts. (WLCC.)

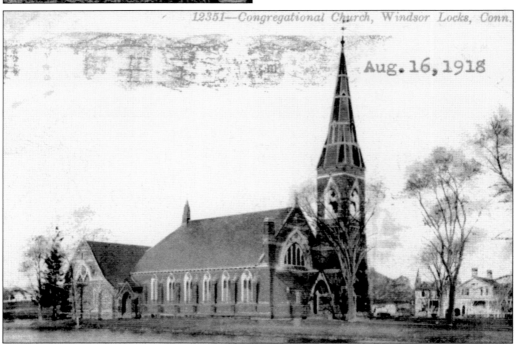

This postcard, donated by William Sizer, shows the Congregational church with a pond beside it. In recent years, the pond was filled in. In its place are now a parking lot for the church and buildings for Dexter Paper. (WLS.)

This chapel stood where the driveway to the Congregational church is now located. This building was used as a chapel until 1847, when the church was erected. Seth Dexter, Herlehigh Haskell, and Harris Haskell were instrumental in the building of the chapel. (WLHS.)

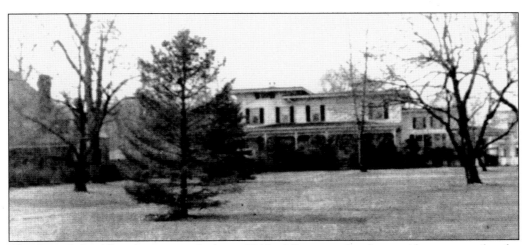

The Rev. S.A. Allen house was built c. 1845. Allen was the first resident pastor for the Congregational church. He served as pastor from 1846 until 1862, when he resigned due to illness. During a revival in 1858, the membership of the church doubled. (WLHS.)

1894 The observance of the Half Century anniversary of this church which
was adjourned from Feb. 28. was held March 28. when the following Pa[p]
were read and by vote of the Church are here recorded.
By Deacon Emeritus Sabre H. Hayden
I became acquainted with the people and localities of Pinemeadow
my boyhood days through my frequent visits to my grandmother Haskell and her fami[ly]
The population of the place was then about one hundred living in 17 house[s]
which were scattered all over the eastern half of the present town of Windsor L[ocks]
Five of these were in this immediate vicinity. Pinemeadow was then with[in]
the township of Windsor, and the Ecclesiastical Society of the old mother church.
to that church five miles away the people went up to worship, with great regular[ity]
on the Sabbath, and the families which I shall have frequent occasion to refer t[o]
the Gaylord Dexter & Haskell, were specially noted for their punctuality at me[eting]
The gospel ministry was then supported by a tax on the property of the members of th[e]
Eccl. Soc. and the tax collector made his annual visits here as elsewhere, and
old Cato collected his annual tax, a sixpence from each family for ringing
the bell on the school house, which stood on Palizado Green, (there was no bell [in]
the Meeting House until about 1805) and the school house bell, under the mos[t]
favorable circumstances could not be heard half way to Pinemeadow. Je[]

The Congregational church holds an amazing piece of the history of Windsor Locks. Jabez Hayden, the town's first historian, wrote the history of the town and church, beginning in the 1800s. The large leather-bound book is still used by the church to record its history. Pictured here is an excerpt from 1894.

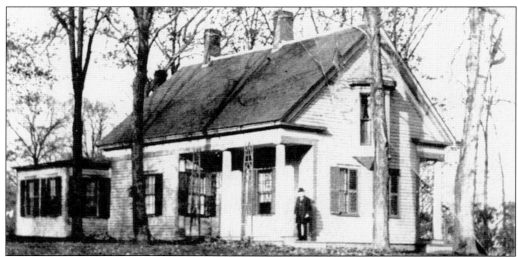

This is the home of Jabez Haskel Hayden, who built and ran a successful silk mill with Hereleigh Haskel. After his retirement, Hayden devoted his time to writing about the history of Windsor Locks. The book he wrote, *Historical Sketches,* was published in 1900. (WLHS.)

Another church that has been an integral part of Windsor Locks is the Church of St. Mary. The chronicle of the church begins in 1824, when the Connecticut legislature chartered the Connecticut River Company to produce the Enfield Canal. Many immigrants came to dig the canal. It is estimated that approximately 400 of these immigrants were Irish. In 1827, one of the Irish workers was badly injured, and a messenger was sent to request pastoral assistance. The messenger returned with Rev. John Power, who arrived in time to administer the last rites. (HSM.)

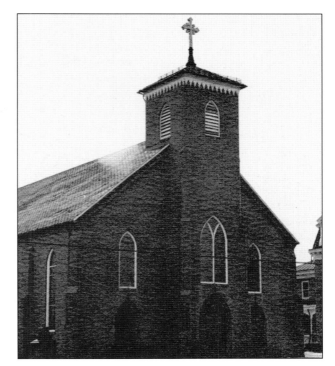

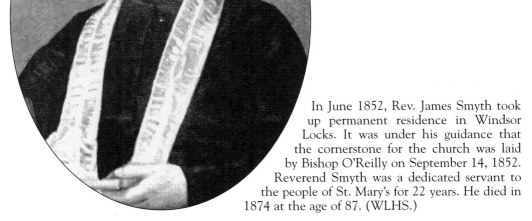

In June 1852, Rev. James Smyth took up permanent residence in Windsor Locks. It was under his guidance that the cornerstone for the church was laid by Bishop O'Reilly on September 14, 1852. Reverend Smyth was a dedicated servant to the people of St. Mary's for 22 years. He died in 1874 at the age of 87. (WLHS.)

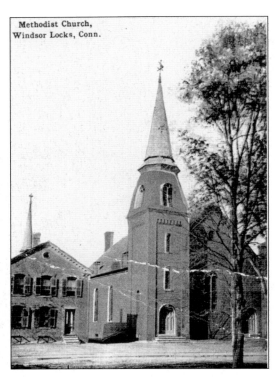

Methodist Church, Windsor Locks, Conn.

This Methodist church stood in Windsor Locks for many years. The church in the background is the Church of St. Mary. The Methodist church has since been torn down and replaced by a parking lot for the Church of St. Mary. (WLHS.)

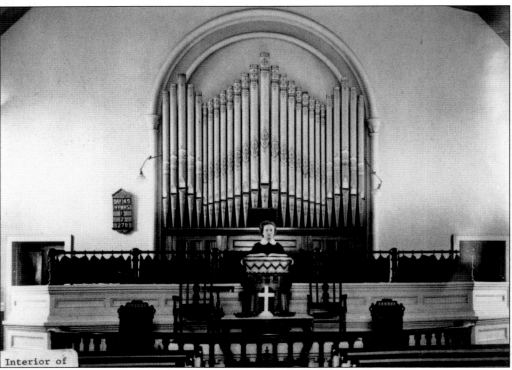

Interior of

Here is a glimpse of the inside of the Methodist church. (WLHS.)

J.E. Mooney stands in front of his home on Oak Street. His store is the building on the left. The top floor of the building was a dance hall, the middle floor was a funeral parlor, and the bottom floor was his store. (WLHS.)

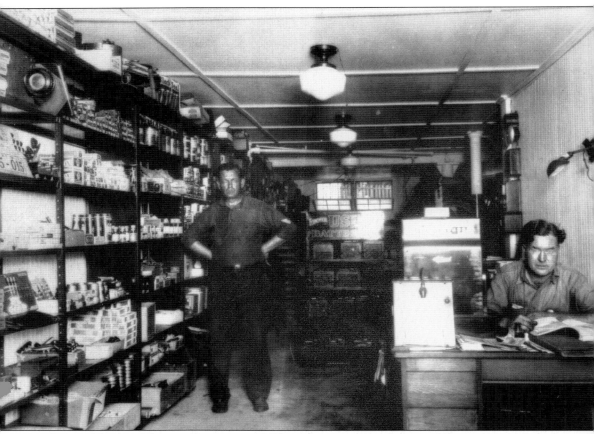

Pictured here is Thomas Dempsey and Elmer Leary in the interior of Dempsey and Leary's service station. (WLHS.)

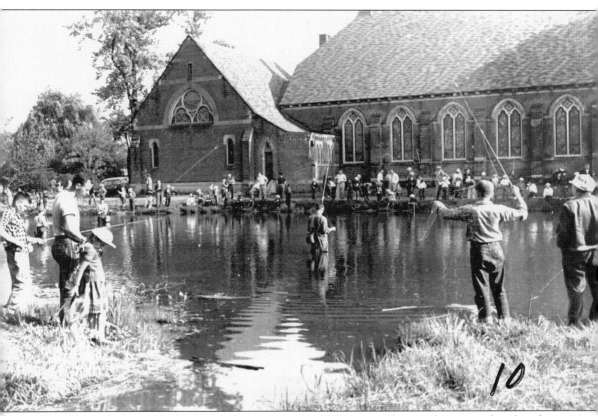

This fishing derby was held during the centennial celebration. The pond next to the church is no longer there. All that is left is a small brook between the church and an office building that belonged to Dexter Paper. Note the little girl on the left, possibly wearing her father's cap. (WLHS.)

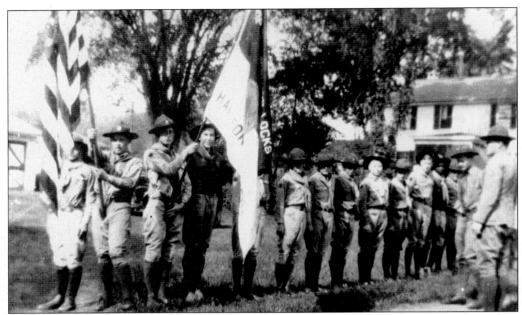

Boy Scout Troop 84 is pictured here *c*. 1926. (WLHS.)

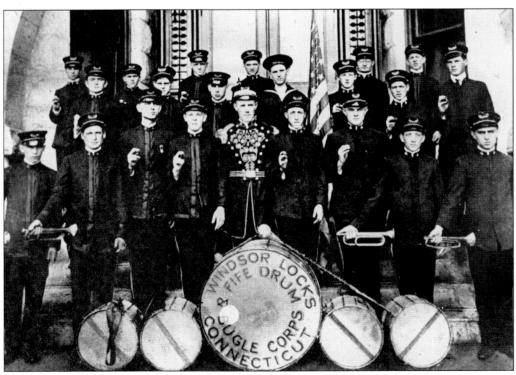

Seen here is the Windsor Locks Fife, Drum and Bugle Corps. (WLHS.)

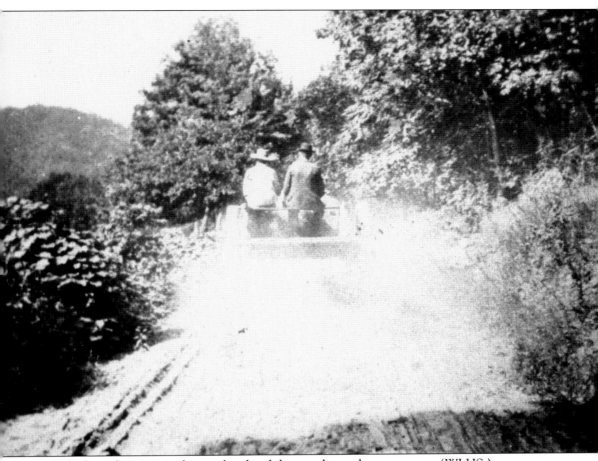

Men kick up the summer dust as they head down a dirt path on a tractor. (WLHS.)

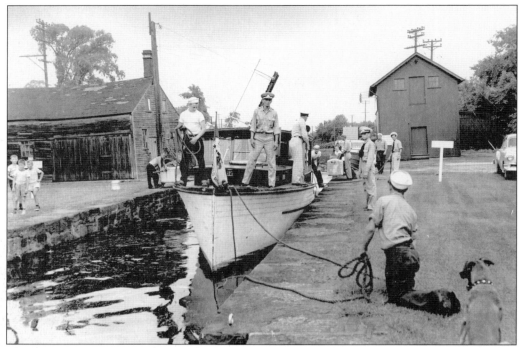

The *Sea Scout* comes into the canal at Windsor Locks. (WLHS.)

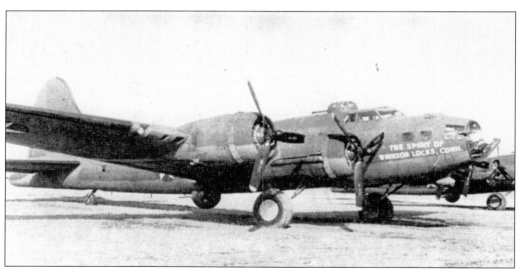

The *Spirit of Windsor Locks* is a bomber plane dedicated to Windsor Locks for the purchase of $177,484 in war stamps and bonds during a six-week campaign. Windsor Locks had the distinction of being the only small town in the country to accomplish this goal. (WLHS.)

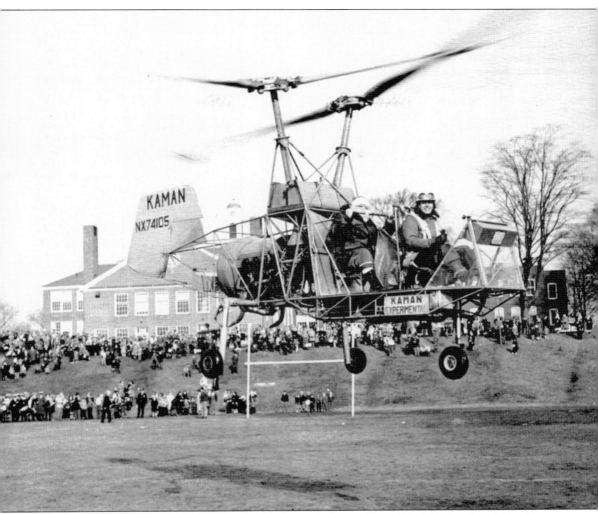

The reindeer are apparently on vacation for this trip. Santa Claus (Fred Barberi) and his pilot, William Murray, land as the police hold back the crowd. Barberi tried to keep his identity a secret, but his son recognized the wedding ring and knew who Santa was. (WLHS.)

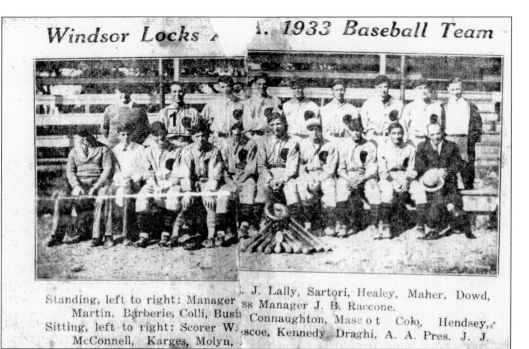

Windsor Locks ... 1933 Baseball Team

Standing, left to right: Manager J. Lally, Sartori, Healey, Maher, Dowd, Martin. Barberie, Colli, Bush ss Manager J. B. Raccone.
Sitting, left to right: Scorer W. Connaughton, Mascot Colo, Hendsey, McConnell, Karges, Molyn, scoe, Kennedy, Draghi, A. A. Pres. J. J.

This is a picture of the 1933 baseball team. Second from the left in the back row is Mike Sartori, who later became a first selectman of Windsor Locks. (KS.)

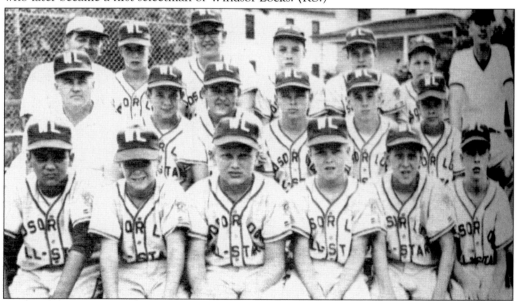

These special young men are the 1965 Little League world champions. They are, from left to right, as follows: (front row) Bob Creech, Mike O'Connor, Phil Devlin, Howie Tersavich, Steve Scheere, and Tom Billick; (middle row) Robert O'Connor (manager), Bruce Akerland, Wayne Arent, Ted Holmes, Bill Boardman, and Bob Rumbold; (back row) Fran Aniello Sr. (president), Mike Roach, Dale Misiek, Al Barret, Fran Aniello, Dennis Dakin, and Russ Mattesen (coach). (WLHS.)

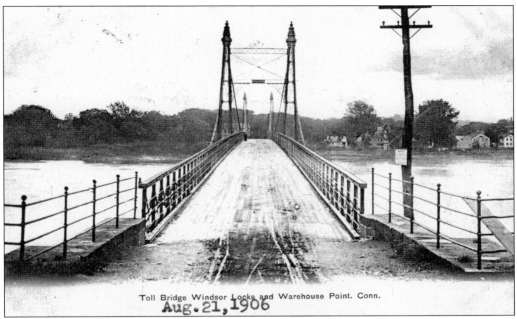

Toll Bridge Windsor Locks and Warehouse Point. Conn.
Aug. 21, 1906

The suspension bridge between Windsor Locks and Warehouse Point is shown *c.* 1906. It was begun in 1853 and finished in 1886. It was originally wooden, as shown here. Until it was freed in 1908, it was a toll bridge. (WLS.)

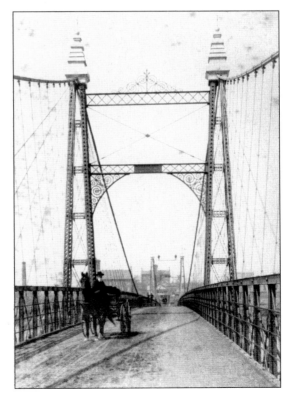

A horse-drawn carriage crosses the bridge. (WLHS.)

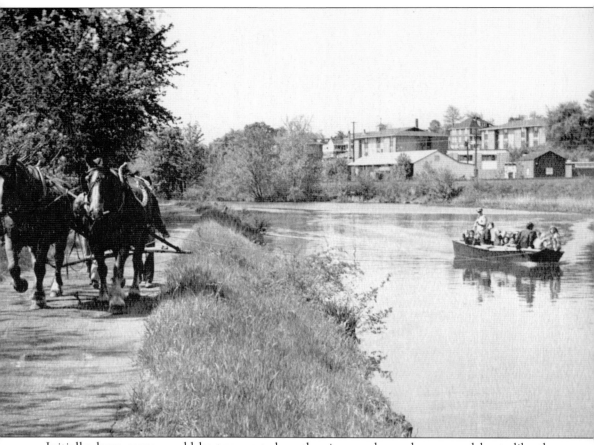

Initially, large cargo would be transported up the river on horse-drawn canal boats like the one pictured here. Amazingly, these horse-drawn boats could carry heavier cargo than the steamships. (WLHS.)

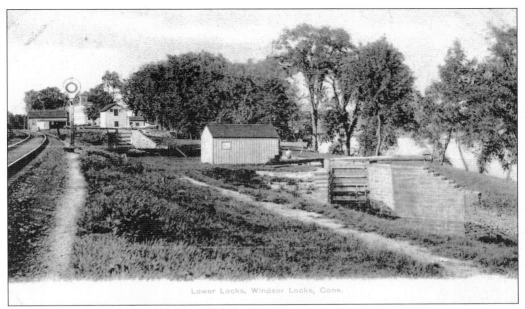

Lower Locks, Windsor Locks, Conn.

This is a picture of the lower locks *c.* 1905. (WLS.)

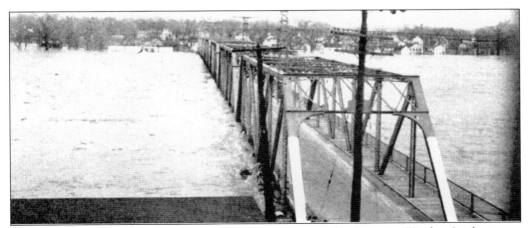

Although the river played a significant role in the growth of industry in Windsor Locks, it was not always kind. In this picture of the 1936 flood, the river begins to recede from the bridge between Windsor Locks and Warehouse Point. The trees along the banks and the houses with water up to the second story (or, in some cases, up to the roof) indicate the threat the river can pose. (WLHS.)

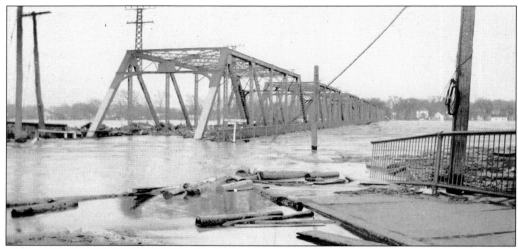

This picture gives us a glimpse of the damage from the 1936 flood. (J.A.F.)

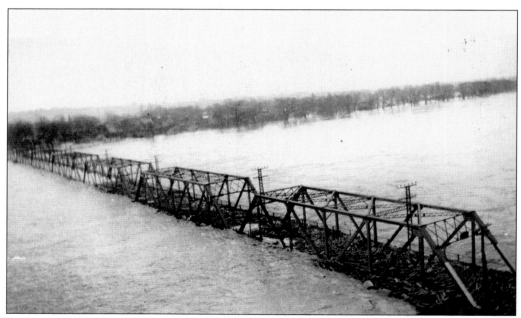

Here we get a bird's-eye view of the damage from the flood. (J.A.F.)

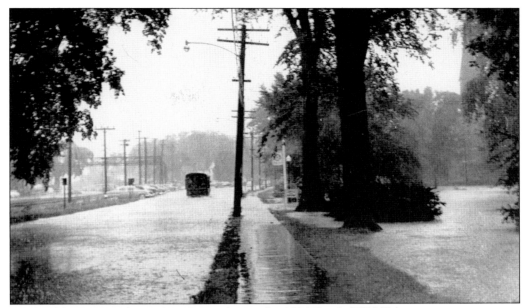

A school bus creeps along Main Street during the 1936 flood. (WLHS.)

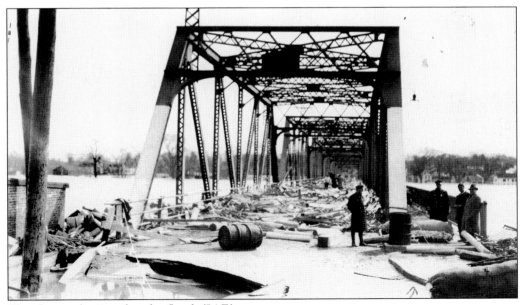

The cleanup begins after the flood. (JAF.)

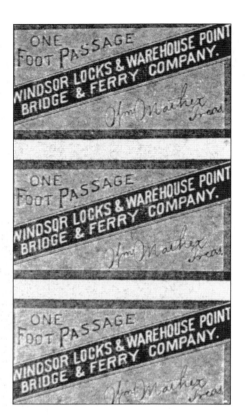

These tickets were used for passage over the toll bridge. (WLS.)

The toll bridge between Windsor Locks and Warehouse Point was the first toll bridge to be declared free. This picture was taken in September 1908 to commemorate the freeing of the bridge. (WLHS.)

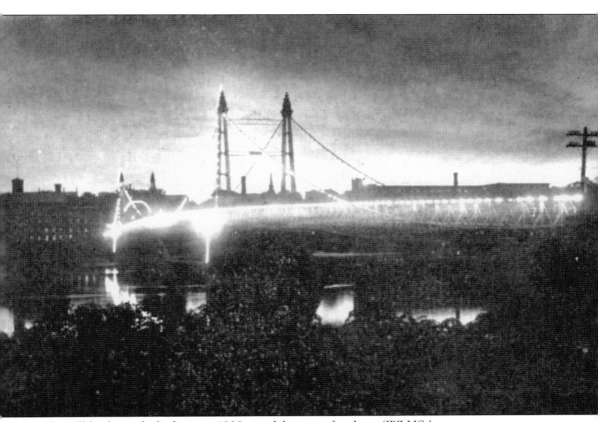

The toll bridge is decked out in 1908 to celebrate its freedom. (WLHS.)

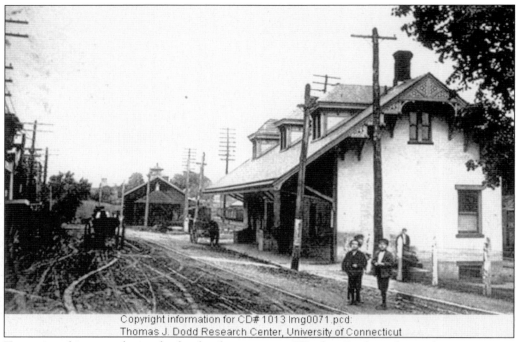

Two young boys stand outside the freight station in Windsor Locks as horse-drawn carriages come to pick up their cargo. Although no longer used as a terminal, the building is still standing. (TJDRC, UCONN.)

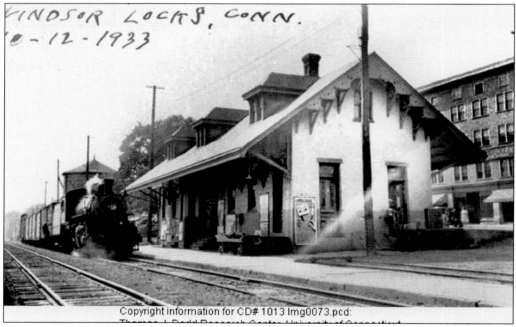

The passage of time brought changes to the station. In this c. 1933 picture, the trees around the terminal have been replaced by a factory, and railroad tracks have replaced the dirt road. (TJDRC, UCONN.)

76

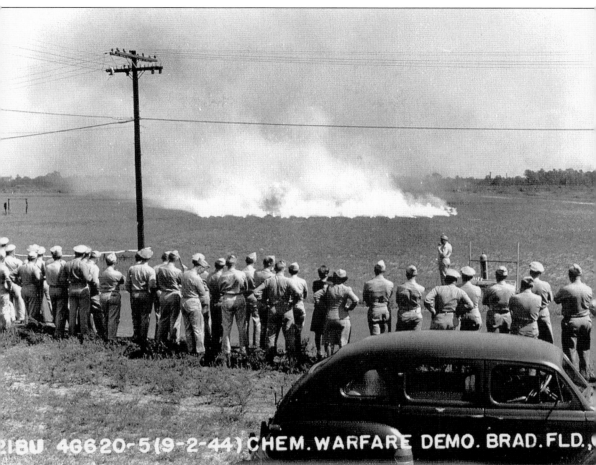

21BU 46620-5(9-2-44) CHEM. WARFARE DEMO. BRAD. FLD.,

Bradley International Airport is on the site once known as Bull Run and originally known as "the Plains." Geologists believe the site was once the floor of an immense lake. The land turned out to be suitable for the growing of Sumatra tobacco, used for the outer wrapping of cigars. Many children in Windsor Locks grew up working in the tobacco fields in the summer to earn extra money. The name of Bull Run has nothing to do with tobacco. The name evolved in January 1872, when a violent murder of two people took place in that area. Local folklore states that the scene was so bloody that it reminded people of the Battle of Bull Run. In the picture above, Bradley Field holds a demonstration of chemical weapons during World War II. (NEAM.)

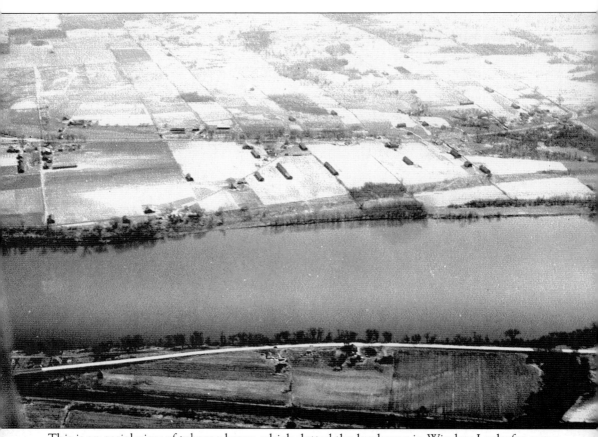

This is an aerial view of tobacco barns, which dotted the landscape in Windsor Locks for many years. (NEAM.)

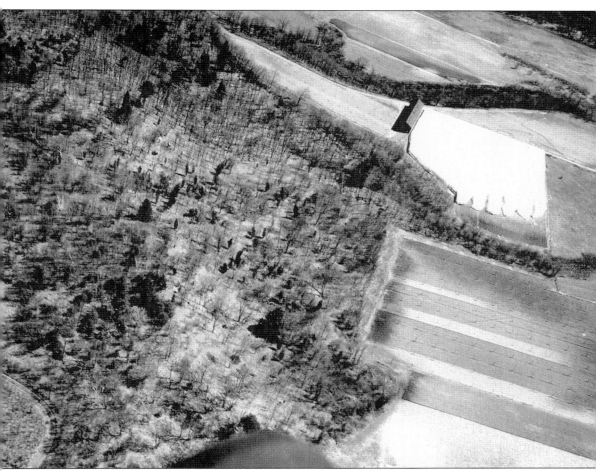

Here we see the tobacco netting in another aerial view. (NEAM.)

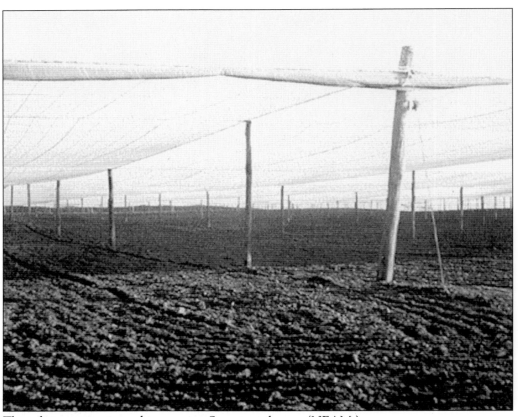

This white netting is used in growing Sumatra tobacco. (NEAM.)

Three

SCHOOL DAYS

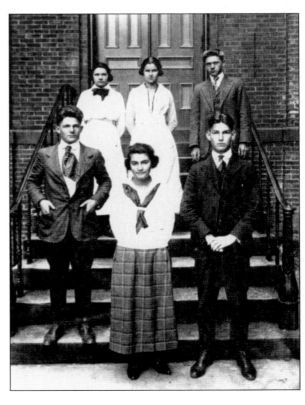

The people in this and the following images grew up, ran things, and now share their wisdom as our senior citizens. Pictured here is a high school class. (WLHS.)

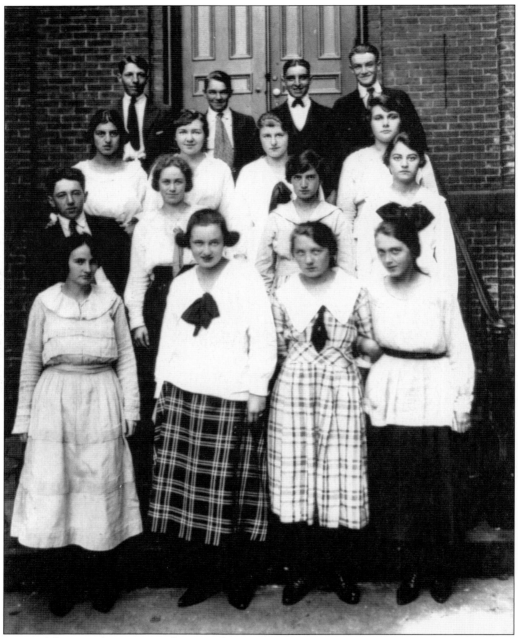

Pictured here is the 1921 graduating class. From left to right are the following: (first row) Frances Dugan, Lillian Nugent, Ceil McNolan, and Helen Gourlie; (second row) Squiggy Magleora, Rosemary McCarroll, Mary Nolan, and Julia Rooney; (third row) Eva Colli, Gertrude Shaughnessy, Anna Malloy, and Mildred Ellis; (fourth row) Ed Shaughnessy, Harold Rupert, Redmond Tynskey, and Joseph Halloran. (WLHS.)

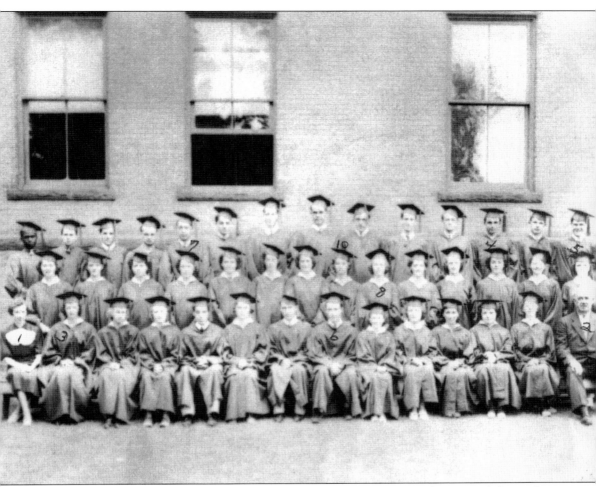

Pictured here is another graduating class. Included in the photograph are English teacher Miss Smith (1), principal Leaner Jackson (2), Betty Shaughnessy (3), Greeno Pelligrin (4), Buddy Hendesey (5), Billie McCue (6), Jimmie Price (8), and Marylin Qunilivan (8). (WLHS.)

This school, built *c.* 1833, was originally located on the southeast corner of Elm and Center Streets. A few years after its erection, it was moved to the northeast corner. It was used as a school until the Union School on Church Street was erected in 1864, and it eventually became a private home. (WLHS.)

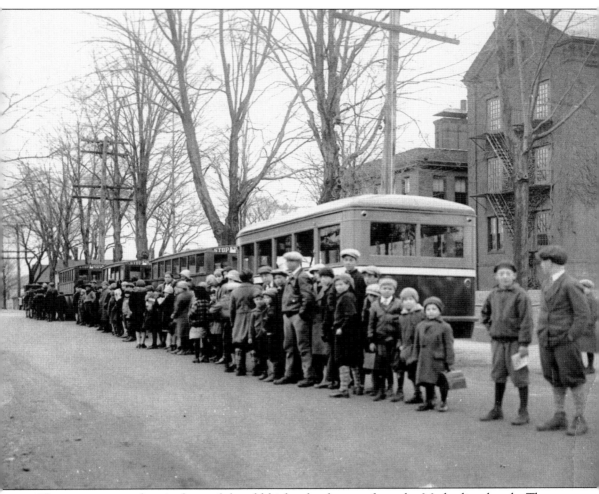

This picture was taken in front of the old high school across from the Methodist church. The lower building was the grammar school. Notice the two taller boys wearing knickers. (WLHS.)

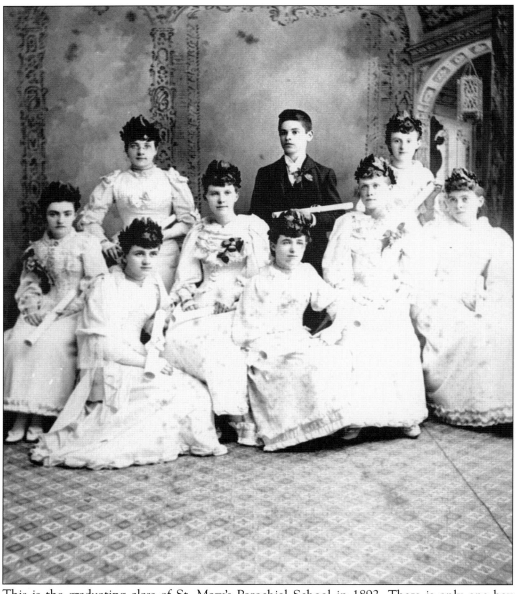

This is the graduating class of St. Mary's Parochial School in 1892. There is only one boy among all those girls. The girls are wearing crowns of leaves on their heads. (WLHS.)

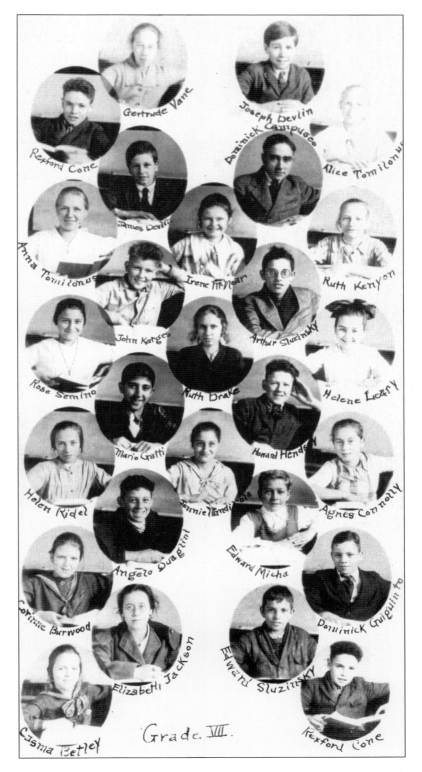

This photograph of a seventh-grade class is labeled for us. (WLHS.)

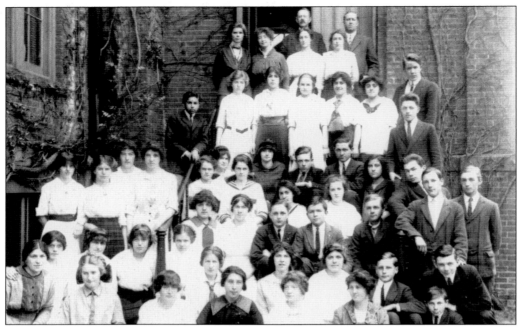

A high school class in 1914 poses in the back of St. Mary's Parochial School. (WLHS.)

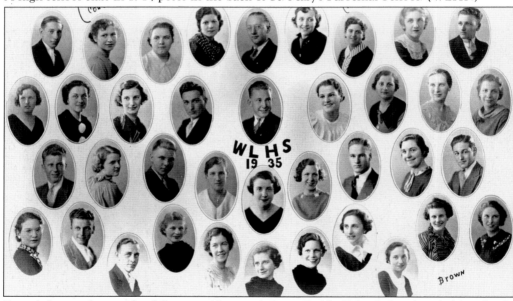

From left to right are the following: (first row) Betty Fields, Felix Pohorylo, Phil Lombardi, Madeline Taravella, Barbara Cooney, Kathryn Wenis, Ann Gicapassi, Lilian Catucci, Dorothy Cavana, Caroline Matroni, and Francis Slusiski; (second row) Teddy Pohorylo, Adele Wolnick, Butch Barberi, Mary Fields, Mary Sartori, Loraine Jenkins, Dave Logan, Mary Racconi, and Glen White; (third row) Mary Molonski, Jenny Sareitta, Mildred Balbi, Joseph Barberi, Frank Merrigan, Ruth Wallace, Mary Colturi, Melvina Draghi, and Carmen Quagliaroli; (fourth row) Joseph Sgorbati, Mildred Sfreddo, Rollande Paquin, Virginia Mangiarotti, Barney Osowecki, ? Uzanua, Elizabeth Sartirana, Katherin McKenna, and Robert Magliora. (EM.)

Here is another grammar school
class. (WLHS.)

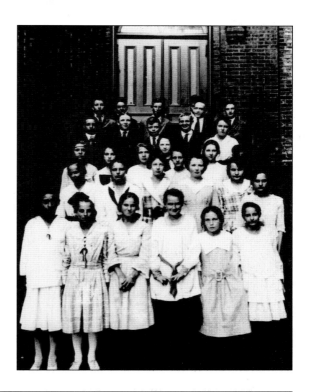

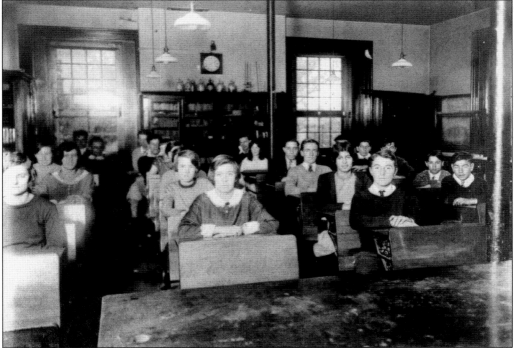

Students in a Union School science classroom sit quietly for a photograph. Note all the bottles
in the back of the room. (WLHS.)

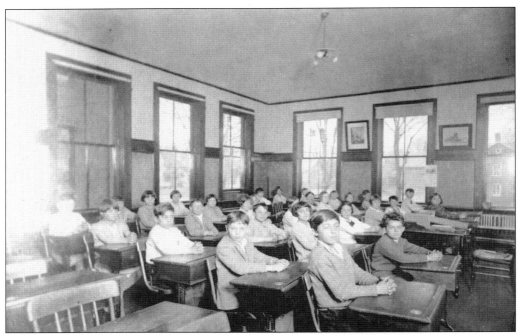

A fifth-grade class poses in the first-floor annex at the Union School. (WLHS.)

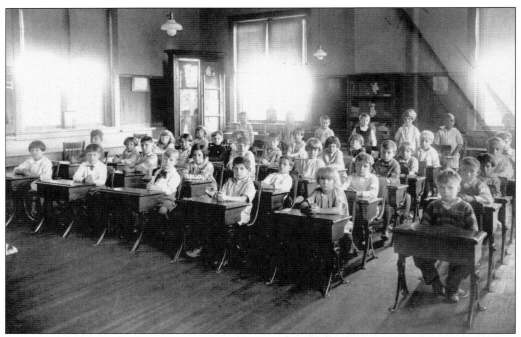

This picture shows a first-grade class at the Union School. The room looks cold and uninviting compared to classrooms today. Notice the drastic difference in appearance between the two boys on the left in neat white shirts with dark bow ties and the boy on the right in the striped shirt. (WLHS.)

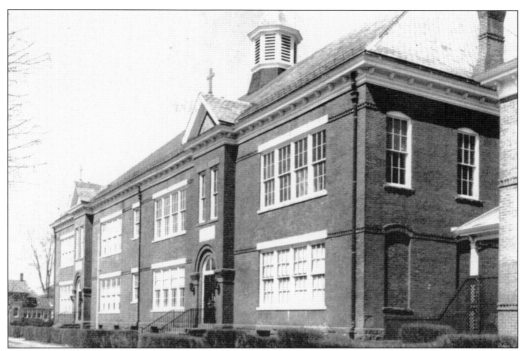

This is St. Mary's Parochial School. (WLHS.)

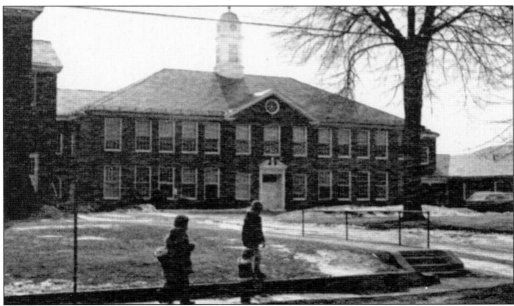

The Union School, pictured here, is now the town hall. (WLHS.)

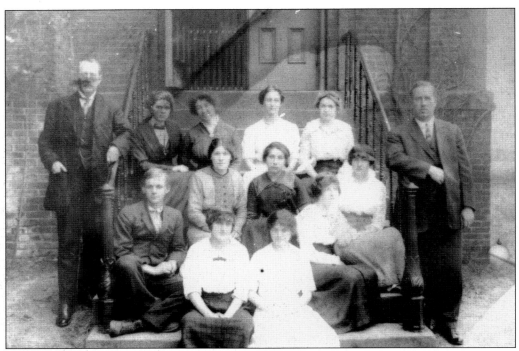

Pictured here is the Class of 1914. (WLHS.)

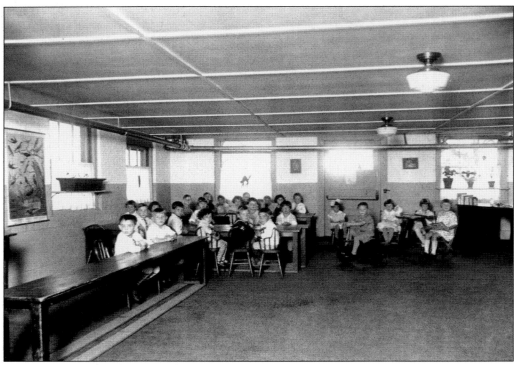

A Union School kindergarten class poses here. (WLHS.)

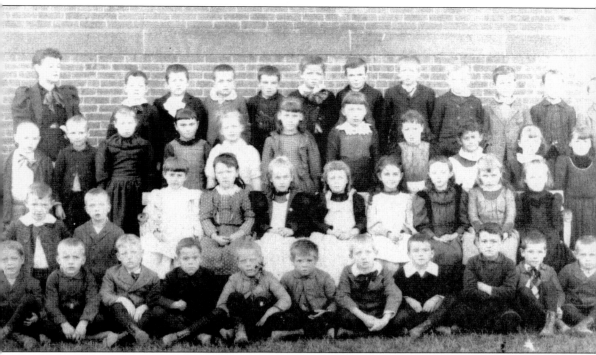

The grammar school students in this pre-1900 photograph are probably from different grades. From left to right are the following: (first row) August Wirth, ? Ginnochi, Bert Shellinton, Russell Abbe, George Wirth, unidentified, Fred Stinson, ? Butler, Oscar Martel, Fremont Cleaveland, and ? Langdo; (second row) Frank Pussey, unidentified, Annie Bidwell, Jennie Burton, Genevieve Bottum, Annie Cleaveland, Carrie Epstien, Louise Ashley, May Seymour, and Hazel Bottum; (third row) James Burns, unidentified, unidentified, unidentified, Ethel Mather, unidentified, Viola Birge, Eva Sutton, Rose Colli, May Egan, and Nettie Birge; (fourth row) Mattie Phelps, Frank Merrigan, unidentified, Ernest Watts, unidentified, John Merrigan, Harry Shaw, unidentified, Spencer Montgomery, George Brown, and Clinton Cook. (WLHS.)

Shown here is a list of children who did not miss a day of school. Note the names John and Lucy Magrassi listed under grade three. John and Lucy were two of the 11 children in the Magrassi family. Their father brought his children over from Italy two at a time. (WLHS.)

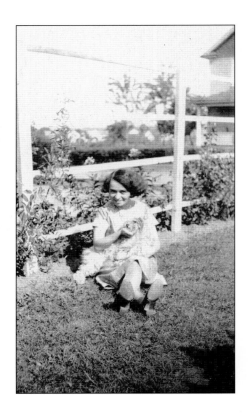

Lucy Magrassi is shown here a few years later. (EM.)

94

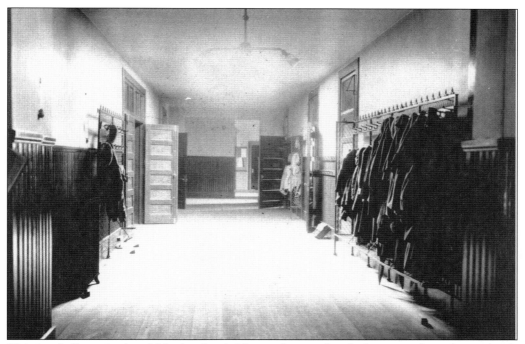

This is a hallway in the old high school. Notice the woodwork that is rarely seen in schools today. (WLHS.)

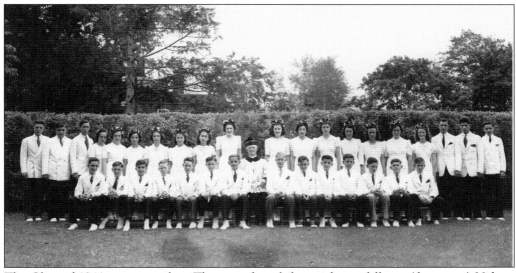

The Class of 1941 poses together. They are, from left to right, as follows: (front row) Videon McCoy, Ramon Colli, Stanley Zimowski, Donald Hendesey, John Durnin, George Wallace, Francis Mobiglia, Fr. Michael Lynch, Charles Nutting, Joseph Fitzpatrick, Edward Sheridan, George Rossi, Louis Preli, Roy Micha, and Glenn Flanders; (back row) Francis Gragnolati, Donald Bevilaqua, Joseph Kupec, Jacqueline ?, Helen Kupec, Irene Castelini, Beverly Hayden, Lorraine Quagliaroli, ? Gardener, Aileen Rouleau, Jule Ann Connor, Dorothy Barberi, Erma Olivi, Madeline Rabbett, Doris Bernocco, Dorothy Nizulek, Pearl McHugh, Charles Wezowicz, Anthony Pelligrini, and George Colli. (JAF.)

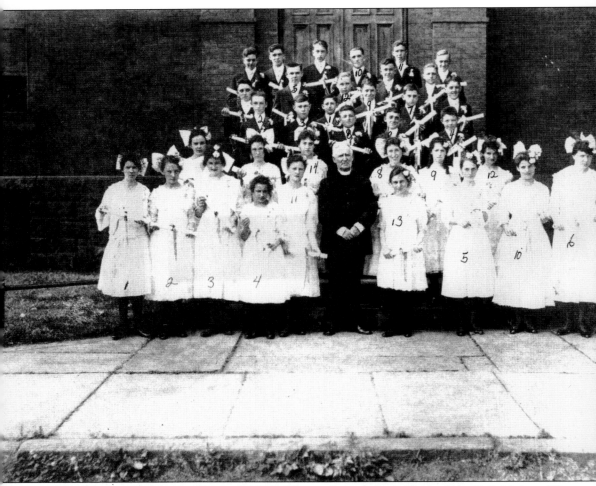

This is the St. Mary's Class of 1921. The girls include ? Healy (1), Ceil Nolan (2), Lillian Nugent (3), Lena Balboni (4), Helen Gourlie (5), Gertrude Shaughnessy (6), Marguerite Fillmore (7), Marion Cannon (8), Mary Nolan (9), Josephine Wallace (10), Anna Mallow (11), Frances Dugan (12), Mae Dunn (13), and Julia Rooney (14). The boys include Ettore Carniglia (1), Joseph Halloran (2), ? Myeres (3), John Shaughnessy (4), Louie Deocie (5), Carlo Biardi (6), Bill Oates (7), Sebastian Botasso (8), Edward Shaughnessy (9), Bernard Oates (10), ? Palmer (11), and George Kennedy (12). (JAF.)

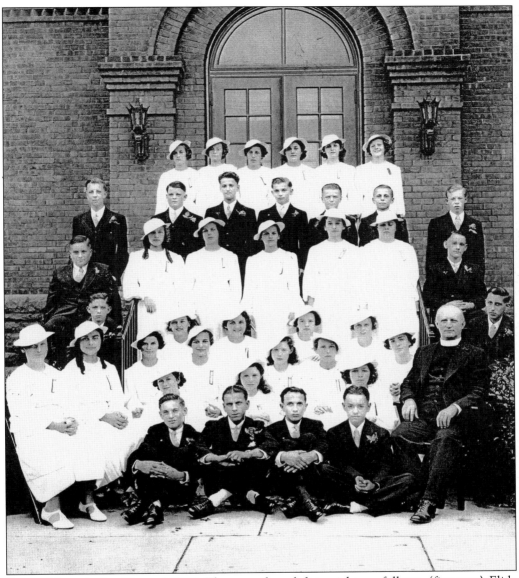

Pictured here is the Class of 1936. They are, from left to right, as follows: (first row) Elida Draghi, Julie Taravella, and Father Lynch; (second row) James Colli, Raymond Oulette, Albert Calseta, and Joseph Belrandi; (third row) Kay Malloy, Ernistine Sartori, and May Cousineau; (fourth row) Jeane McMahon, Dorothy Maher, Loraine Magleora, Mary Thierry, and Betty Burk; (fifth row) Ann Delnero, Wanda Ostrowski, Mary Balf, and unidentified; (sixth row) Desolina Taravella, Irene Ouellette, K. Delnero, Justine Anzulioz, and Gloria Granolati; (seventh row) James Wheeler, Francis Ciparelli, Silvio Quagliaroli, Chester Prebit, and James Dursa; (eighth row) Barbara Micha, Kay Mather, Norma Quagliaroli, Elenor Gariloi, Marian Hinkley, and Marian Bassinger; (outside left) Edward Peoples, Alfred Gragnuloti, and Sam Flanders; (outside right) John Brown, Robert Malloy, and Joseph Albani. (WLHS.)

Pictured, from left to right, are the following: (first row) Frank Mallory, Angline Therrien, Mary Raccone, Melvina Draghi, unidentified, and John Gubala; (second row) Monica Cooney, Ruth Wallace, Father Conlon, unidentified, Mary Little, John Queen, and Mary Stick; (third row) Joseph Scorballi, Dorothy Cavano, unidentified, Elizabeth Sartirana, Margret Balbi, Mary Kane, Nelli Quagliaroli, ? Mcphee, and Jackie Williams; (fourth row) Walter Seaha, Rollonde Paquin, Roy English, Barbara Cooney, Robert Magliora, Frank Merrigan, Genevie Chiparelli, Charles Ambrosetti, Sabina Cannone, and ? Stick. (EM.)

Four

HEROES AND UNSUNG HEROES

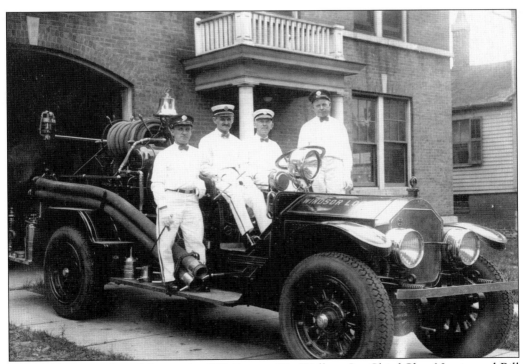

Pictured here are, from left to right, Bill Queen, Gio Wallace Sr., Chief Chas Norris, and Bill Sullivan. (WLFD.)

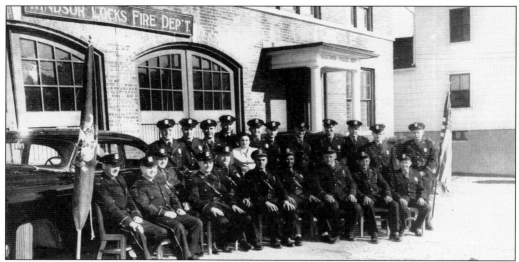

No chapter on town heroes would be complete without the police force, pictured here c. 1953. From left to right are the following: (front row) William Sidway, Alexander "Archi" Draghi, Theodore Fisher, Albert Pearce, Anthony Senia, Chief James Henry Whitten, Lt. Russell Jubrey, Charles Walton, James Lynch, and George Harvey; (back row) Maurice Thibodeau, Charles Sanborn, Charles Alekson, Edward Savino, Irene Oulette, Patsy Lanti, Arthur Mayo, Ronald Walters, William Byers, Fredrick Scripo, Bernard Kulas, and Stanley Stroney. (WLPD.)

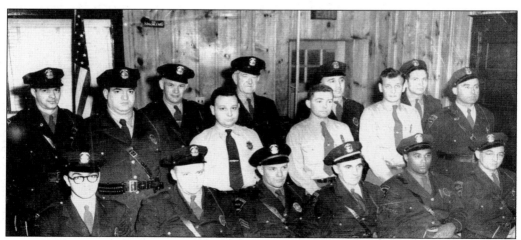

Pictured here are the police c. 1954. They are, from left to right, as follows: (front row) Emmet Murphey, Charles Walton, Lt. Charles "Washy" Walters, Chief James Henry Whitten, Lt. Russell Jubrey, and James Lynch; (middle row) Anthony Senia, dispatcher Alexander "Archie" Draghi, dispatcher George Harvey, Charles Sidway, and Charles Alekson; (back row) William Byers, Ronald Walters, Edward Silk, Patsy Lanati, and Charles Rachel. (WLPD.)

Just as important as the police department is the fire department. Pictured here is the first fire chief, J.E. Egan, who served from 1890 to 1906. (WLFD.)

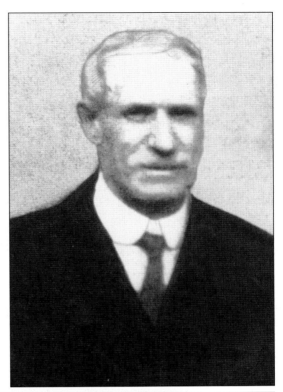

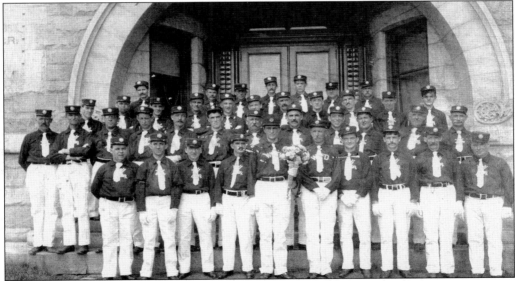

Members of the fire department pose in front of Memorial Hall on July 4, 1904. They include, from left to right, the following: (first row) Hugh Boyle, Tom White, Tony Johnson, Tom Reed, Chief Horace Daub, Tim McCarthy, Frank Nolan, Redmond Drett, Pete Maher, and Jack Sheehan; (second row) P.T. McCue, W. Woodworth, F. Graiton, Leo Egner, Mike Hart, Charlie Mahoney, Ed Maher, Pat Burns, John Durnin, Dick Carroll, Mel Darby, and Mike Little. The rest are unidentified. (WLFD.)

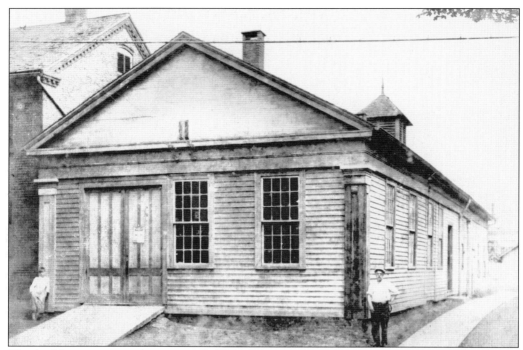

This building was once the town jail. (WLHS.)

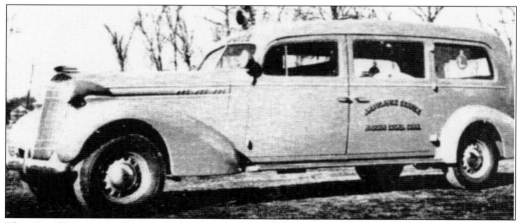

This is the town's first ambulance, a 1936 Oldsmobile. It was purchased in 1944 for $1,650. (WLHS.)

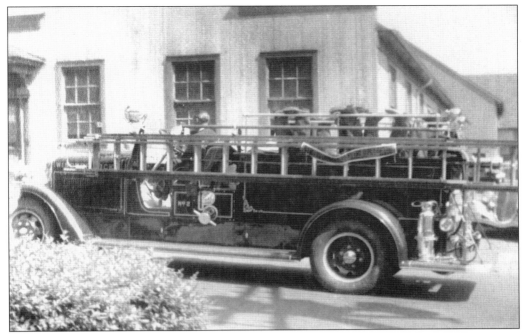

Art Russell sits in Old Engine No. 2. (WLHS.)

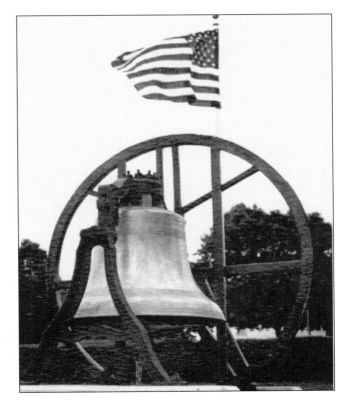

The town's fire bell is seen here. It was donated by the Medlicott Company in memory of deceased firefighters. (WLHS.)

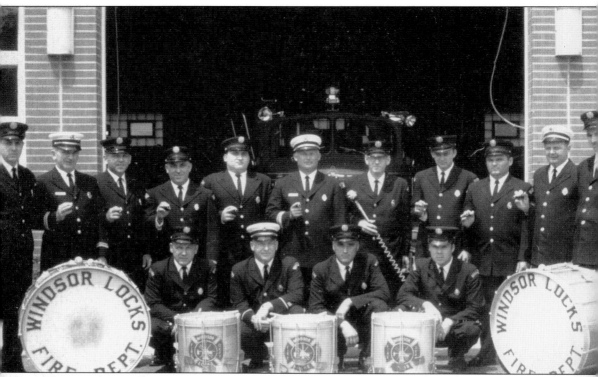

The Windsor Locks Fire Department Fife and Drum Corps is seen here on Memorial Day in 1969. The drummers are V. Ignazzio, D. Blomquist, E. Knight, D. Ribaudo, J. Loughran, and F. Kaplan. The fifers include J. Colli, M. Wezowicz, F. Spalluto, F.Dibbella, W. Rielly, and E. Macdougald. (WLFD.)

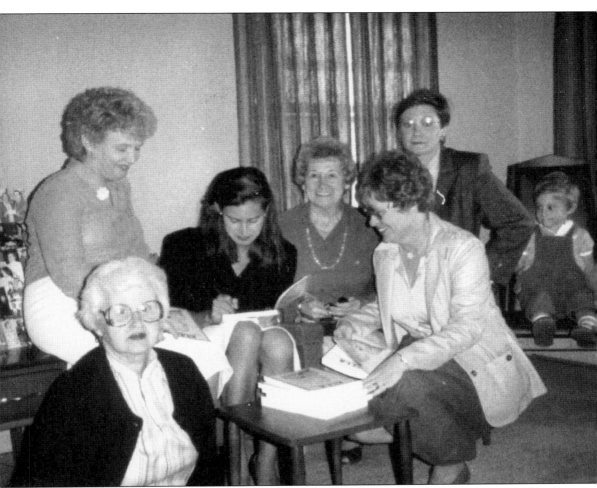

Every town has unsung heroes as well. Windsor Locks is fortunate to have groups such as the Women's Club, pictured here at Ella Grasso Day in 1985. The club was founded in 1955 as a community volunteer organization and established its first scholarship in 1958. Club members are Ophelia Martel, Alice Lennon, Susan Bysiewicz, Linda Chapple, and Beverly Church. (WLWC.)

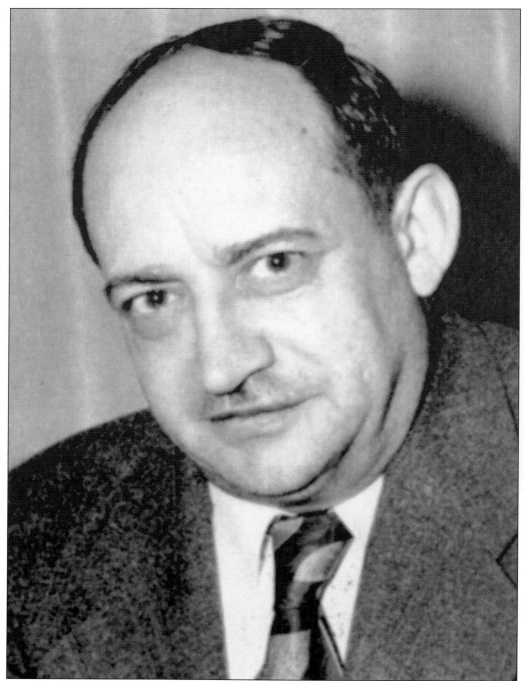

Dr. Ettore F. Carniglia was an unsung hero of incredible proportion. He grew up in Windsor Locks and went to Harvard for medical school. After graduating in 1931, he returned to Windsor Locks to serve the community. He is said only to have slept about three hours a day. At night, his wife drove him from home to home as he made house calls. He was also known nationally as one of the best diagnosticians available. (WLHS.)

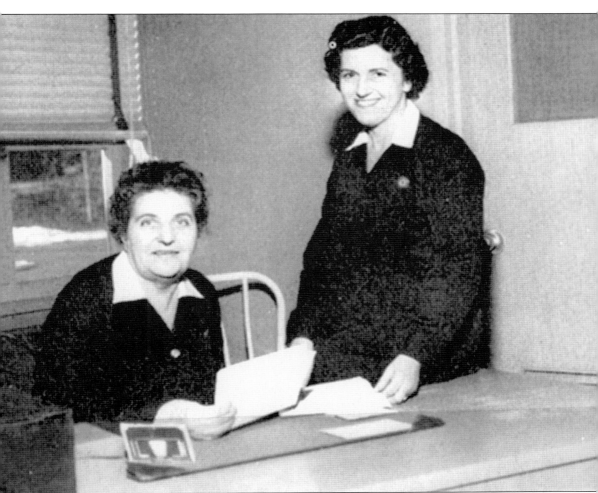

Another group of unsung heroes began as the Public Health Nursing Association in 1920 and later became the Visiting Nurses Association. The dedicated nurses served the community and schools with their skills. Their devotion to the town was and still is invaluable. Pictured here *c.* 1960 are Irene Bahre (left) and Elizabeth Magnani. (EM.)

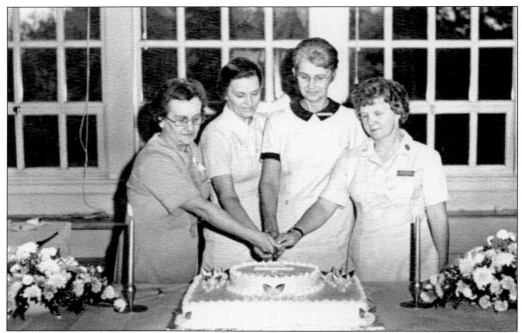

Pictured here is another group of dedicated nurses who worked for the Windsor Locks Public Nursing Association. They are Lorraine Pearce, Marguerite Brown, Marian O'Leary, and Ann Stroud. (WLHS.)

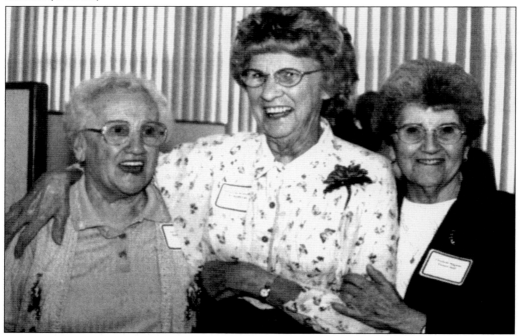

Marguerite Brown (center), pictured with Lorraine Pearce and Elizabeth Magnani, was recently awarded the prestigious Florence Nightingale Award for a lifetime of outstanding service in the nursing profession. She is truly an unsung hero. (EM.)

Five

PRECIOUS MEMORIES

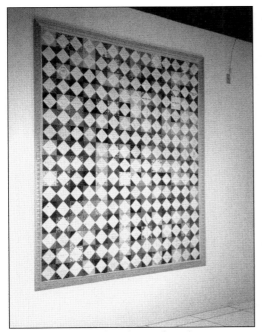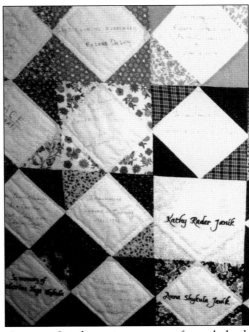

The Memory Quilt is located in the senior citizens' center. It is hung in memory of people both living and dead.

The man on the left, Roco Magrassi, pictured with his son, Aldo, brought his wife and 11 children over from Provincia Di Pavia Allesandria, Italy. Due to the cost, he brought his children over two at a time, leaving his wife to tend the farm in Italy with the remaining children. (EM.)

Elizabeth Magnani's mother, Malia Magrassi (standing on the left) married Anthony Sartirana (seated). The couple came from the same province in Italy and met here in Windsor Locks. A number of families came right from Ellis Island to Windsor Locks. (EM.)

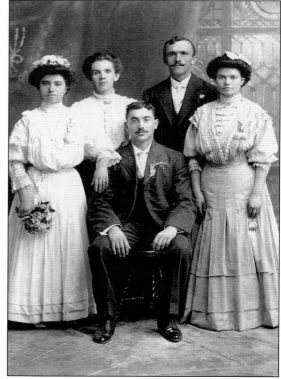

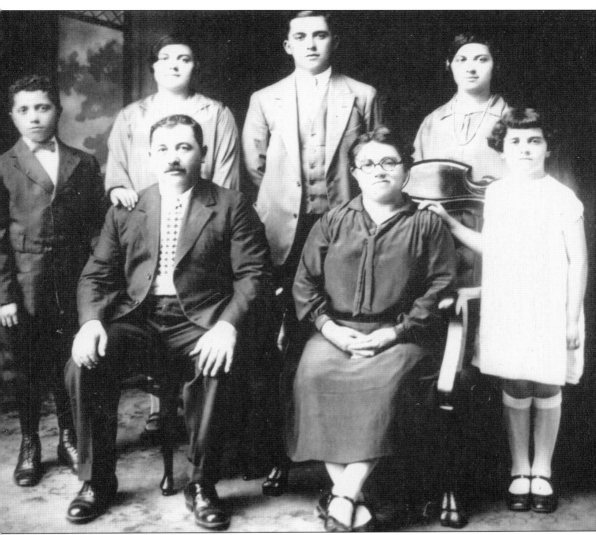

This is the Sartirana family. Seated are Anthony Sartirana and his wife, Amalia Magrassi Sartirana. Standing behind them are their children, from left to right, Aldo, Josephine, Armand, Assunta, and Elizabeth. (EM.)

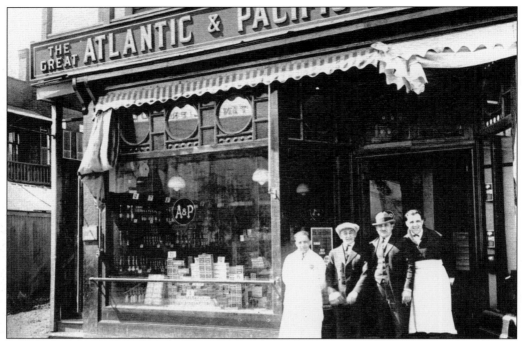

The A & P shown here was very popular among the residents of the town. The store owners treated the residents with kindness and allowed them to run a tab when money fell short before the next payday. On the far left is Jimmy Franklin, and on the far right is Jimmy Riley. Dances were held weekly above the store. A number of immigrants met their future spouses at these dances. One happy couple who met at a dance became the parents of Katie Scotto. (WLHS.)

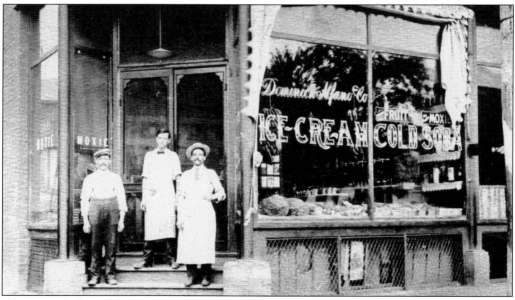

These men look as if they are waiting for the fourth member of their barbershop quartet. (WLHS.)

Pictured here is Ella Tambussi on her wedding day. She became Ella Grasso and was the first woman governor to be elected in Connecticut. She grew up in Windsor Locks and was active in town politics. Many of the town's seniors still have fond memories of growing up and going to school with Grasso. Sadly, Grasso died in 1981. (WLHS.)

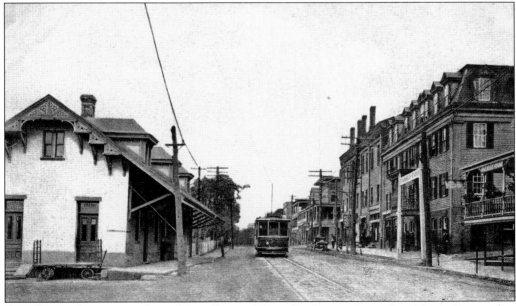

A trolley makes its way down Main Street. The tall white sign on the right indicates that there are stables for horses in the back. The sign that hangs slightly behind it advertises a boardinghouse. (WLS.)

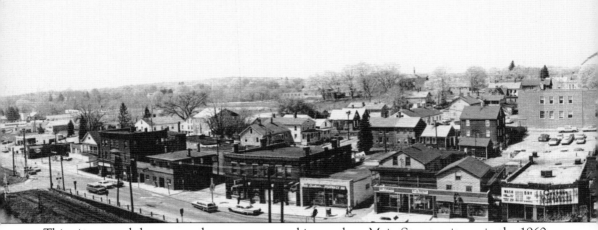

This picture and the one on the next page combine to show Main Street as it was in the 1960s, prior to the redevelopment project. The picture hangs in the homes of a number of senior citizens who still mourn the loss of their beloved Main Street. The building with the arch was

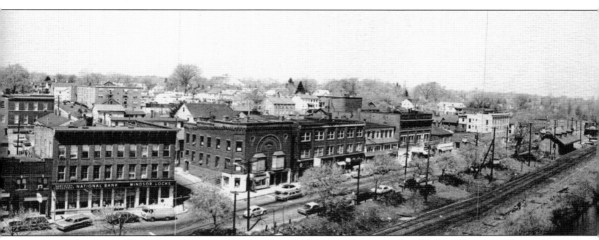

once the post office. Another popular landmark that was lost was the Rialto Theater. The train station, on the far right, is the only Main Street building that still stands today. (WLHS.)

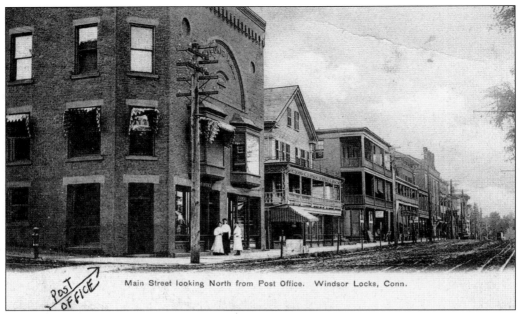

Main Street looking North from Post Office. Windsor Locks, Conn.

POST OFFICE

Main Street is just a dirt road in this picture. The post office is on the corner. Michael Smalley remembers being able to look out his window and watch as the dirt road to the left of the post office was paved for the first time. The second floor of the building to the right of the post office was the public library. (WLS.)

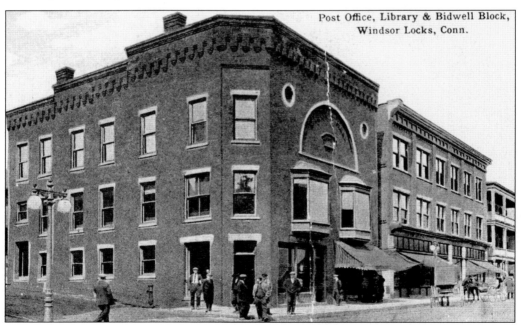

Post Office, Library & Bidwell Block,
Windsor Locks, Conn.

Although the dirt road is still there, things have changed a bit on Main Street from the previous picture. Note that the library no longer has the porch on the second floor. The third building on the right is the Bidwel Building. Bidwel's was a prominent business in Windsor Locks through the 1950s. (WLS.)

John Taravella and his wife came over from Italy and raised their family in Windsor Locks. Many Taravellas still live in town. (JL.)

Pictured here are two descendants of John Taravella, Andrew and Romilda Taravella. Another descendant, Julie Taravella Lynes, still lives in Windsor Locks. (JL.)

Romilda Taravella (Julie Lynes's mother) is pictured on the left with her mother, Mary Daglio, and her sister Lena. (JL.)

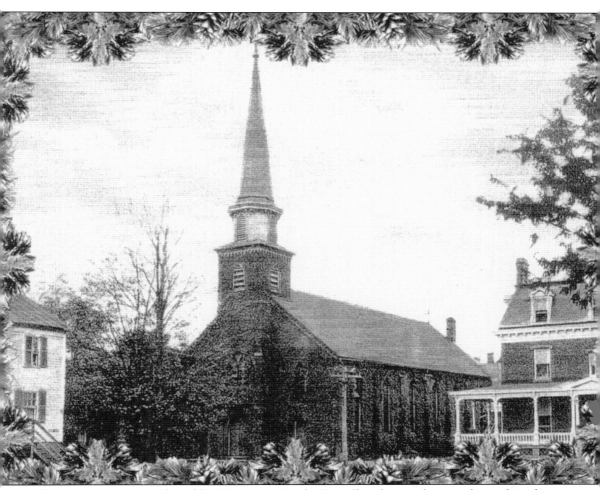

This picture was contributed by Mary Ann Basile Gianelli, who was born and raised in the building to the lower left, across from St. Mary's. Her father ran a shoe shop that was in the very front of the building. She still lives on Spring Street, just a few houses away from where that building once stood. She proudly tells people that she was born on Spring Street, has lived on Spring Street all her life, and will be buried in the cemetery on Spring Street. (MG.)

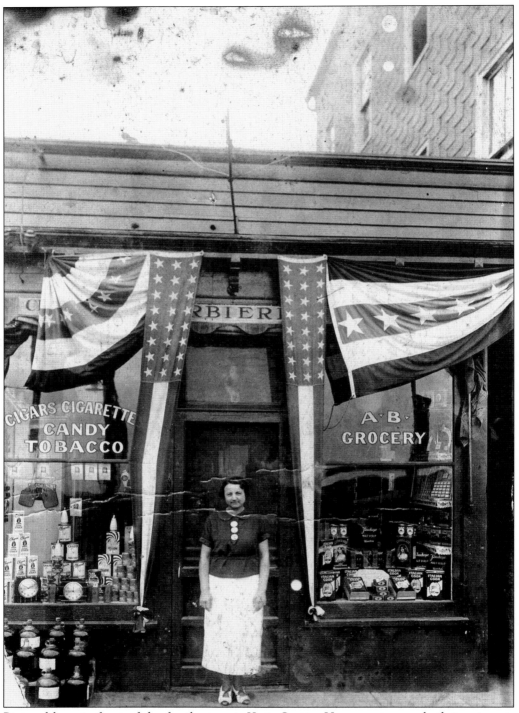

Pictured here in front of the family store is Katie Scotto. Her parents were both immigrants from Italy. They were also very determined young people. (KS.)

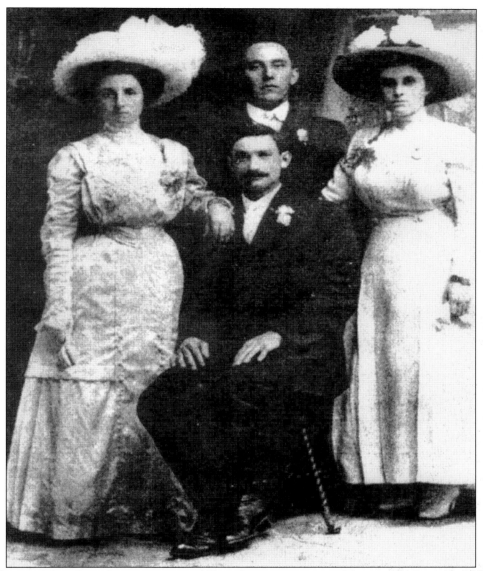

Albert and Josephine Scotto, parents of Katie Scotto, are pictured here on their wedding day. According to Katie, her mother was sent back to Italy upon first arriving in America; the doctor who examined her at Ellis Island assumed she was sick because her eyes were red and swollen from crying. About eight months later, she was back on another ship and this time was successful. Her sponsor was a cousin in Windsor Locks. She was put on a train with a tag that read, "WL, Connecticut." Josephine arrived here unable to speak English. Soon, she was working in the Montgomery plant, making thread from cotton.

Katie's father, Albert, lived with friends in New Britain, Connecticut, when he first came to America. He was unable to find a job and heard rumors of many Italians finding work in Windsor Locks, so he walked the 26 miles to get there. By the time he arrived in Windsor Locks, he had worn his shoes out. After making inquiries, he walked another six miles to a paper mill where he found work. For an entire week, he walked the six miles each way. By the end of the week, he had enough money to buy a bicycle. (KS.)

Pictured here, standing between her parents, is Mary Pasco. Her sister is on the right. Mary's mother always fed anyone who came to her door. When young Mary asked her mother why she did that, her mother explained that if the man at the door was her own father, she would want someone to feed him. (MTP.)

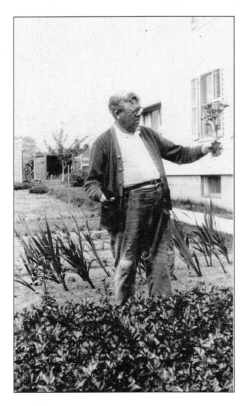

Leonard Pasco is shown in his garden. Mary Pasco remembers people from the town coming to buy her father's celery plants for 1¢ apiece. The garden did not make them much money, but it was her father's pride and joy. (MTP.)

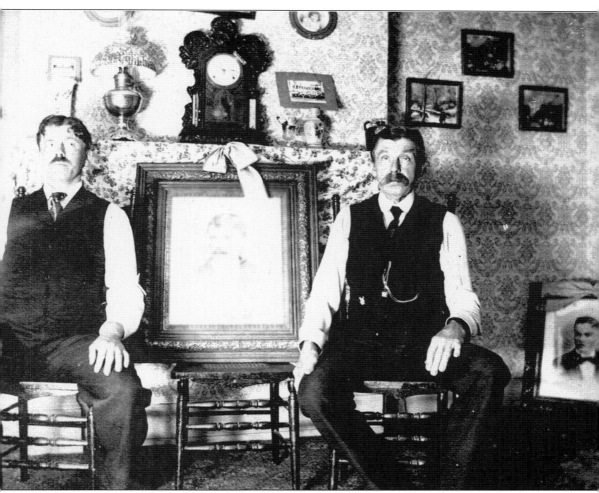

Leonard Pasco is pictured with his father, Daniel Pasco, at a wake. Back then, very few people could afford embalming, and it was also costly to keep a body on ice for a few days. The custom at the wake was to drape a picture of the deceased and have the family sit by the picture. (MTP.)

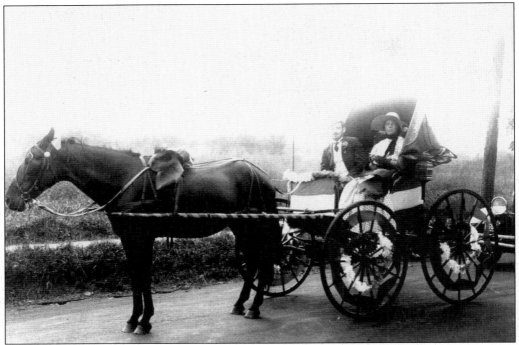

Making it through the first 100 years was cause for celebration. The beloved Dr. Ettore Carniglia and his wife, Blanche, ride in the centennial parade. (WLHS.)

Teddy Pohorylo, John Driscoll, Florence Pohorylo, and Hazel Reed (in the back with a parasol) commemorate the centennial with a trip down memory lane. Notice the top hats worn by the men. When the one-horse wagon first came to town in 1815, the ride was a bit uncomfortable, as springs had not yet been invented. (WLHS.)

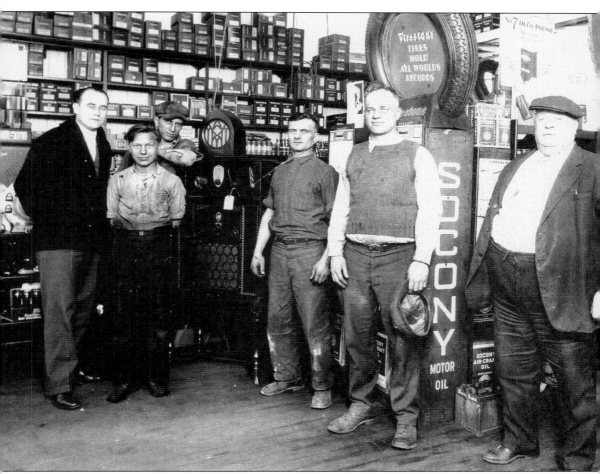

Pictured here is the crew at Cutler's Tire Store. The man second from the left is Michael Smalley. The radio shown is a Peerless radio, and the boxes on the shelves are tire tubes. Many of the tires today are tubeless, but there was a time that each tire needed a specific inner tube. (MS.)

This home, owned by Michael Smalley, was built from timbers belonging to one of the theaters at Bradley Field. After World War II, some of the buildings at Bradley Field were demolished. People who wanted the lumber could take it. Smalley, with the help of friends and family, took some of the wood and built this lovely home. (MS.)

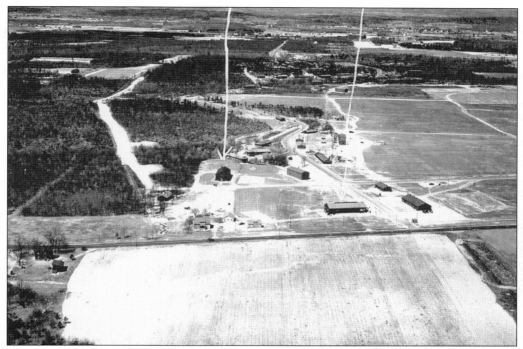

These pictures show the building believed to be the theater demolished after World War II. It was the theater closest to the main road, indicated by the arrow on the right in the above photograph. In the photograph below, the theater would be the building on the bottom left. (NEAM.)

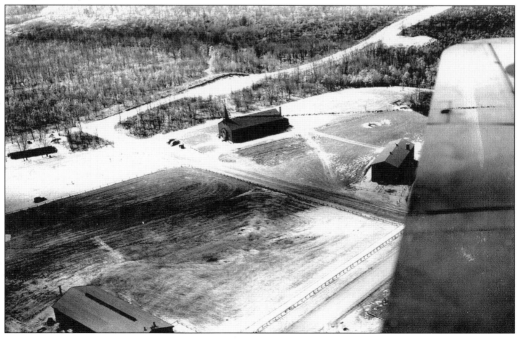

Pictured is the Preli family in 1932. Standing in back is Eleanor Preli, who later became Eleanor O'Leary. The Preli family originally came from Italy. One Christmas season, according to Eleanor's son Cornelius O'Leary, Rose Prelli, seated here in the front center, decided to make some raviolis and take them up to one of the "Yankee" women on the hill, probably Mrs. Mather. In return, Mrs. Mather presented Mrs. Preli with a mincemeat pie. After trying the pie and loving it, Mrs. Preli called on Mrs. Mather to see if she would teach her how to make this wonderful new pie. Mrs. Mather replied that she would love to, if Mrs. Preli would teach her how to make the "curiosities." To this day, it is a Christmas tradition in the homes of Mrs. Preli's descendants to serve both mincemeat pie and ravioli. This story illustrates the heritage that makes Windsor Locks so special. (CO.)